IMAGES
of America

ITALIANS OF THE BAY AREA

THE PHOTOGRAPHS OF GINO SBRANA

ON THE COVER: The Italian truck farmers had a unique way of interweaving the leaves of the produce in preparation of their load for transportation. This allowed the vegetables to be stacked without the need of wooden vegetable crates, as well as insuring their freshness to the buyers at the Colombo Produce Market. These Colma farmers, standing in front of a Kleiber truck, are holding many of the vegetables, including carrots, cauliflower, beets, turnips, and parsnips. Two of the men in this 1924 image, identified by Elsie Pollastrini, are Petroni and Orlando Disperati. According to Frank Siri, who began farming in the 1920s near the Cow Palace, there were at least 57 varieties of produce grown in that area by Italians, including dandelion root—unheard of these days.

IMAGES
of America

ITALIANS OF THE BAY AREA
THE PHOTOGRAPHS OF GINO SBRANA

Carlos Bowden Jr.

ARCADIA
PUBLISHING

Published by Arcadia Publishing
Charleston SC, Chicago IL, Portsmouth NH, San Francisco CA

Printed in the United States of America

Library of Congress Catalog Card Number: 2006926305

For all general information contact Arcadia Publishing at:
Telephone 843-853-2070
Fax 843-853-0044
E-mail sales@arcadiapublishing.com
For customer service and orders:
Toll-Free 1-888-313-2665

Visit us on the Internet at www.arcadiapublishing.com

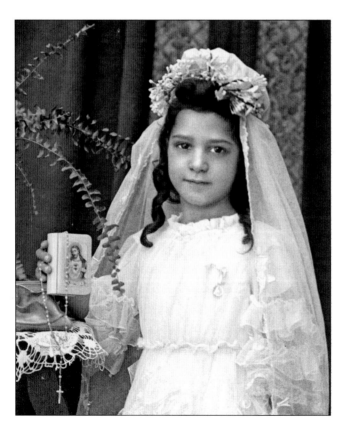

In a country where little effort is afforded to rescue and preserve works of some of this country's finest artisans and photographers, oblivion seems all too often the destiny of so many of these national treasures. Such is the story of all lost and forgotten works of art, of song, of poetry, and of photography, abandoned by a society unburdened by the need or desire for culture. Such was the story of Gino Sbrana. This book is dedicated to all those whose efforts shall, in one way or another, fundamentally enlighten society, thereby insuring, artistically and culturally, the enrichment of all our futures. I truly hope this little book at least serves to assist those whose histories are somehow touched by this imagery.

CONTENTS

ACKNOWLEDGMENTS

First I would like to thank Canadian Betty Workman (1918–2003) for her artistic endeavors, which led to her being given the original Sbrana glass negative collection, which in turn led to her visit to the Old Methodist Church in Ferndale, which then led our paths to cross and a friendship to form. I would like to thank longtime friend Paul Skofield, for answering the church door when Betty came visiting in Ferndale. I would like to thank another longtime friend, Michel Allaire, also Canadian (1951–2002) for the assistance in researching the history of these Italian images and furthermore, for his countless hours dedicated to hand-tinting all of the photographic murals in the Gino Sbrana Exhibition we created together in 1988. I would like to thank Andrew Brunetti, the nephew of Gino Sbrana, for sharing with me his stories of Uncle Gino, which have added substantially to our understanding of who this master of photography was. I would like to thank Randy Hicks for computer assistance in the high-resolution scanning of the entire Sbrana glass plate negative collection. I would like to thank another longtime friend, Michael Jenner, for her computer assistance in the digital photographic restoration of the Sbrana imagery and for the high-resolution scanning of both the early Sbrana original prints and the recently acquired Sbrana film negatives.

I would like to also thank all those who have in some way contributed to the details of this book, the names, dates, places, etc., for these memories add to the historical foundation of Italian culture, awareness, and well being, for now and in the future. I want to especially thank those I met in person who were photographed by Gino Sbrana. These include Al Lanza, Andrew Caviglia, Mary Garibaldi, Elsie Pollastrini, Amadeo Gonella, Larry Capelli Jr., John Garibaldi Sr., Tosca Sbrana Moran, and Andrew Brunetti. Their stories and identifications have added greatly to the understanding of Gino's long-forgotten imagery.

For those who wish to contact me, please write to Carlos Bowden Jr., P.O. Box 1048, Ferndale, California, 95536. For those of you who are interested in seeing the Gino Sbrana imagery online, please visit www.chuckbowden.com. Questions and comments will be welcomed in regard to this book. There will also be information offered relative to identifying and finding other Sbrana imagery that still waits to be discovered. Along with the writing of this book, my contributions also included photo editing, photo sequencing, typing, text editing, and research (interviews and exhibitions).

INTRODUCTION

This book is a visual record of the Italian community of the San Francisco Bay Area, preserved as it was, 80 more or less years ago, by the camera of Gino Sbrana. The collection of more than 600 glass negatives may be the definitive and most comprehensive historical record of Bay Area Italians of that time period left in existence, especially in regard to the Italian farming community.

From the darkened room where glass plates come to life could be heard a voice singing *La Boheme*. Hour after hour, the neighbors on Locust Street in San Jose could hear one song after another, as faces magically appeared where once there were none, in the backyard studio of photographer Gino Sbrana. Yes, it was just another day in the early 1920s for Gino. And why not sing? The negatives of his recent photographic expeditions up to the vegetable farms of the peninsula and the East Bay, to capture the various Italian gatherings and Sunday afternoon farm parties, were all coming out of the developer beautifully sharp, and this was more than enough to make his heart sing. The preservation of memories for future generations is what his camera was meant for, and for over 20 years, this is what he had done in the San Francisco Bay Area. Sadly, however, for the next 60 years tomorrow never came. The history of the lives of those Italians frozen in time on his glass plates were nearly a forgotten memory, never to return.

In late summer 1985, it was just another day for me in Ferndale, taking my two white wolves for a walk up Russ Park to Zipporah's Pond, where they would play in the moss-covered waters to cool off as I contemplated life beneath the redwood canopy. Back at the old Methodist church in which I was living, unbeknownst to me, a woman with an interest in seeing the large, beautiful stained glass windows of the church came visiting and knocked on the door. My roommate greeted her and gladly showed her around the church to see the windows. Noticing some of my antique camera equipment sitting around, she mentioned having boxes of old glass negatives and then promptly left. I returned to the church from my hike to hear the story of the lady with the glass negatives. I was more than interested in meeting her and knowing more about the glass negatives, but, I came to discover, she left no name or number. With zero clues at hand to find her, I decided my roommate and I should immediately go from store to store in Ferndale until we found her. Luckily, after a short search, we located her in Etter's Gallery, where Betty Workman first told me of the glass plate negatives she had been given, found beneath the studio apartment where she was living on Locust Street in San Jose. This is how I learned of the Sbrana images, and this is how remarkably close the lost history of Bay Area Italians came to never being known at all.

Betty Workman's initial interest in making stained-glass lamp shades out of the glass negatives, turned out to be the reason Marie Sbrana gave her the entire glass-plate collection, and in turn, led to their escape from the oblivion of a San Jose basement. Once Betty came to understand the nature of my photographic interest in the glass plates, she understood that by giving me the collection, its preservation would be insured and its historical significance might be discovered. Our coincidental and fortunate crossing of paths is where the Gino Sbrana story began.

Gino Sbrana was born in 1879 in Pisa, Italy. In 1894, he and his family, including his two brothers, Olinto and Carlo, his mother, and father, Giuseppe, immigrated to the United States. The Sbrana family took up residence in San Francisco. Records indicate that in 1902 there was a "Sbrana Bros. Fruits & Vegetables" located at 220 Broadway. In 1912, the photographs of J. B. Monaco show the Pisa Foto building, which Gino and Carlo founded, having just been built at 533 Broadway. Gino met Marie Rubino of Oakland at the California Packing Corporation in that city and married her in 1913. That year, Oakland directories indicate a "G. Sbrana Photographer 356 Myrtle St. Oakland." Apparently, love won over his initial San Francisco business inclinations and drew him across the bay to relocate in Oakland, leaving Pisa Foto to his brother Carlo. Marie and Gino continued to live in Oakland along with their two young daughters, Jeannette and Tosca, until 1918, when the family decided to move to San Jose. Gino built a small, backyard portrait studio and darkroom at the new family house at 757 Locust Street and continued his successful dual careers as a photographer and boiler-room engineer for Del Monte and Defurry Canning. On New Year's Eve, 1925, while leaving Oakland to return to San Jose, Gino's Chevrolet was hit by a drunk driver, resulting in internal injuries to Gino's chest. The injury eventually led to the demise of his photographic career. Gino died in San Jose in 1947 and is buried at Santa Clara Mission Cemetery.

For more than 20 years, this is pretty much all I knew about Gino, for as far as history was concerned, Gino the photographer did not exist. Even today, there is no mention of Gino Sbrana anywhere in any book or on the Internet. Although I am not Italian, my interest in rescuing Gino from oblivion is based on my enthusiasm for photography, combined with the fact that these images were remarkably intriguing. I was determined that neither the historical significance of the Sbrana collection nor his photographic talents would be lost or forgotten.

When you start from scratch with a box of 70-year-old glass negatives of unidentified people, facts are not few and far between—they just do not exist at all. The only facts I knew for sure were the name of the photographer, Gino Sbrana, and where his collection was found— San Jose. Undaunted by this challenge, I decided to take matters into my own hands to research the photographs by creating a large traveling exhibit of hand-tinted photographic murals and showing them directly to the Italians of the San Francisco Bay Area. So, in 1988, my Canadian friend Michel Allaire and I went to work on a mural exhibition printed directly from the Sbrana glass plate negatives. I did the printing, mounting, and framing, while Michel beautifully hand-tinted all of the larger images from 30 inches by 40 inches to four feet by eight feet. In 1989, the large Sbrana exhibit was shown in numerous San Francisco locations, including the Mills Building, Club Fugazi, Museo Italiano Americano, and Festa Italiana. The Italian community first began to recognize both the historical significance and the beauty of Gino's long-forgotten imagery through these exhibitions. Names, dates, locations, and stories began to be revealed, as I had hoped. Finally, the lost photographic treasure began to be discovered and appreciated by the public.

But still, who was this historian with a camera who had so diligently documented thousands of Italians of the San Francisco Bay Area so masterfully, and yet, had become so completely forgotten? To try and answer who Gino Sbrana was, as a photographer and as a person, would require finding someone who knew him personally. I recalled having been told that Gino had a young photographic assistant and nephew by the name of Phil Brunetti and that Phil had a younger brother named Andrew. Earlier this year, once the go-ahead was given for the publication of this book, I was able to retrace some of the steps and research I had done back in 1988 and was able to find Andrew, who turned out to be a gold mine of information. He gave generously of his time and spoke at length of the old days and his recollections of Uncle Gino. The fact that his mother, Jennie Rubino, was the sister of Gino's wife, Marie Rubino, and that both families lived in the San Jose area, and that his brother, Phil, was Gino's assistant, all greatly contributed to the thorough and intimate understanding of this long-lost master photographer.

Andrew was born in 1919, and his earliest memories of Gino would coincide with the time the majority of the images seen in this book were created. Andrew recalled in great detail the fond

memories of sitting next to Uncle Gino and going on Sunday afternoon drives with his family to the orchards around the San Jose area. Andrew spoke very highly of Gino, remembering him as a wonderfully kind, generous, and fascinating uncle who very much influenced his own direction in life. Andrew recalls hearing Gino sing opera in the darkroom as he developed and printed image after image in his backyard photographic studio. Andrew also spoke of watching, with fascination, on several occasions, as Uncle Gino colored photographic enlargements of his work with a hand-pump airbrush.

Andrew also spoke of the stories he had been told by his brother Phil, who was 10 years older and had been adopted by Gino to be his photographic assistant. Gino and Phil often traveled together on photographic expeditions in Gino's Chevrolet to many of the Italian farms and ranches of the Bay Area to photograph family gatherings, celebrations, or get-togethers for any variety of occasions. Once the car had been loaded with all the photographic essentials—the large full-plate wooden camera, a tripod, a dark cloth, and the many film holders loaded with light-sensitive glass plates—they would be off to do portrait work at one of the ranches.

Gino's long career and skills as a portrait photographer were greatly admired and known in the Italian community, leading to a steady flow of portrait commissions all over the Bay Area. Gino's pre-1906 association with the Italian farmers and ranchers, while working with his brothers in San Francisco as a fruit and vegetable distributor, is more than likely what led to a lifelong affiliation and friendship with the Italian vegetable farmers.

Not only were Gino's talents as a professional photographer greatly appreciated and admired, so too, according to Andrew, were his talents as an opera singer. This rare combination of talents meant that when Gino and Phil traveled to the ranches to do commissioned portrait work, whether for Italian get-togethers or Sunday afternoon farm parties or doings of any sort, people would be waiting to greet the two. Gino and Phil would first do the photographic preparation, finding the soft light suitable for the portraits needed, in the shade of a tree or house or inside a barn. Next the tripod and wooden camera with leather bellows and brass lens would be set up, and the subjects would be gathered together for the portrait.

For each exposure, Gino would set the f-stop to the largest aperture setting, then put a large dark cloth over his head and camera so as to be able to see the faces projected onto the ground glass at the back of the camera. Focusing the image by means of rack and pinion adjustments, he then quickly took the dark cloth off, set the f-stop on the lens to the needed aperture, cock the shutter to the needed speed of 1/30 of a second (or thereabouts), grab a wooden film holder (containing the light-sensitive glass plate), and carefully insert it into the back of the camera. He pulled out the dark slide so that the plate was ready for exposure, then, when the time was right, squeezed the rubber bulb, forcing air through a hose to trip the shutter, thereby allowing the focused light of their faces to instantaneously strike the plate. Finally, Gino would push the dark slide back down to seal in the dark, the now latent (6.5-inch by 8.5-inch) image waiting to be developed.

Once each of the needed exposures had been carefully made and the equipment returned to Gino's Chevrolet, the dinner festivities would begin. These events would be followed by many requests from the dinner guests to hear Gino's beautiful operatic voice. This talent was so greatly admired that he was known to have given outdoor concert performances at the University of Santa Clara Theatre. Gino, who knew many operas by heart, loved to sing and would do so whenever possible, whether in the darkroom or in concert or at these Italian farm parties. On many occasions, late in the evening, Gino's voice could be heard over the fields of cauliflower and through the leaves of the eucalyptus trees on both sides of the San Francisco Bay singing *Tosca* and *La Boheme*. Andrew recalls how his brother and Uncle Gino would not arrive back home in San Jose until ten or so in the evening.

These stories paint an unbelievably colorful picture of a profession not usually noted for opera-singing photographers. I suppose, when one comes to realize the degree to which Gino pursued the mastery of his profession, to which his captivating and timeless portraits attest, with their ever-present soft light characteristics, with their integrity of ambience, with their touch of flowers

and intrigue, and with their spontaneous nuances existent from image to image, along with his love of family and Italian community, then yes, maybe Andrew was right when he describes his Uncle Gino as somewhat of a romantic bohemian. Who would have ever believed such beautifully moving imagery could have existed for so long, undiscovered and unappreciated. To think of how close to oblivion this story really was only leads one to wonder how many other lost image treasures are out there waiting to be discovered.

This is a detailed photograph of Gino Sbrana around 1925 when he was 46 years of age. The full image can be seen on page 13.

One

GINO SBRANA
FAMILY AND HISTORY

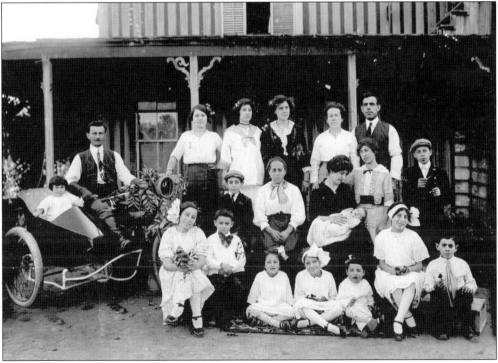

This is a gathering (possibly in Oakland) around 1918 of some of Gino Sbrana's relatives. The young girl and man on the motorcycle are not identified, but pictured, from left to right, are (first row) unidentified, Phil Brunetti (Gino's photo assistant), Jeannette Sbrana (Gino's daughter), Irma Brunetti, Tosca Sbrana (Gino's other daughter), Salvina Sbrana Rubino, and Joey Rubino; (second row) young Phil Rubino and his grandmother Catherina Rubino (mother of Joe Rubino), Rose Rubino Capelli (holding baby Larry Capelli Jr.), Catherine Rubino Tramontona, and Tom Rubino; (third row) unidentified, Jennie Rubino Brunetti (pregnant with Andrew), Marie Rubino Sbrana (Gino's wife), Maria Rubino, and husband Joe Rubino. Andrew Brunetti first identified this photograph.

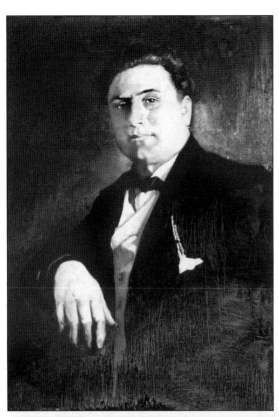

This wonderful oil painting of Gino Sbrana was done by Canadian Michel Allaire of San Francisco. Michel (1951–2002) was a friend of the author who helped create the Sbrana Hand-Tinted Mural Exhibit, shown at Festa Italiana. The printing of the photographs was done by the author, and Michel did the hand-tinting. This painting is based on the photographic likeness of Gino found on his tombstone at the Santa Clara Mission Cemetery.

Gino Sbrana, along with brother Carlo, founded Pisa Foto at 533 Broadway in San Francisco in 1911. Two years later, Gino married Marie Rubino from Oakland and opened a studio there at 356 Myrtle Street. Another Gino stamp found gave an address of "1171–73 7th Street," also in Oakland. The final photographic studio was established in 1918 at 757 Locust Street in San Jose.

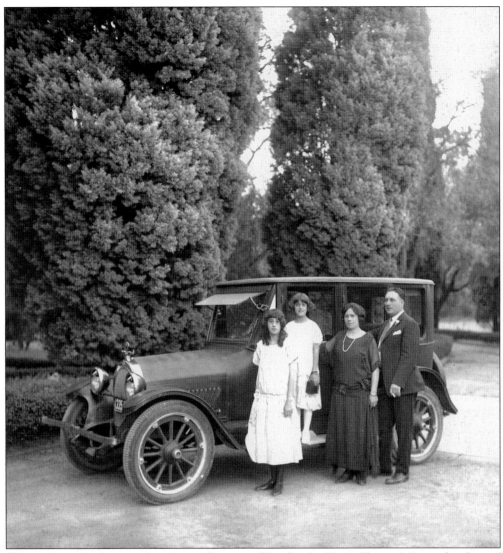

This is the only photograph of Gino Sbrana and his family. Tosca Sbrana Moran, daughter of Gino Sbrana, identified this photograph. From left to right are Gino's daughters Jeannette and Tosca, Gino's wife, Marie (Rubino), and Gino Sbrana. This mid-1920s photograph was taken at the Hearst estate in San Simeon and may have been taken by Gino's photo assistant and nephew, Phil Brunetti. Apparently, Gino left no records to indicate whom he photographed, nor where and when his photographs were taken, so the distance he traveled to do portraiture is not certain. However, every single image that has been identified so far is in the San Francisco Bay Area, with the only exception being this image of the family on an outing to the Hearst Estate and Castle.

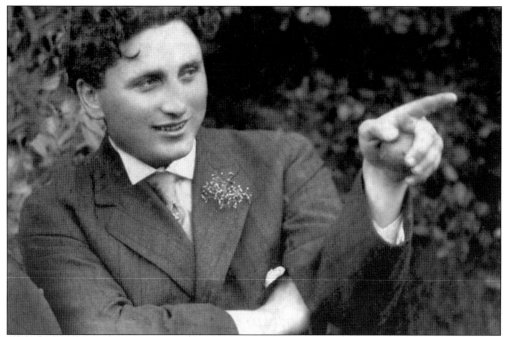

This close-up of the photograph below is of a 17-year-old Gino Sbrana. Upon close inspection of Gino's hands, one may come to the conclusion that he was the photographer. This image suggests that Gino may have already begun developing his photographic skills in Pisa, even before immigrating to the United States in 1894.

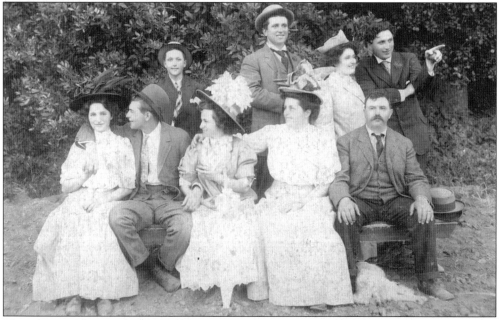

This photograph was taken around 1896 in San Francisco. Gino is on the right side in the back row. Not many records have been uncovered detailing Gino's early years. The majority of the images seen in this book came directly from the glass plate negatives found in the basement of Gino's studio, while a few early images came from the original family prints.

This is another close-up of Gino Sbrana, from the image below, taken just a few years later, c. 1899. Gino's nephew Andrew Brunetti described Gino as both a Dapper Dan and a romantic bohemian. These early photographs of Gino seem to support this idea. Many of the images in this chapter were saved by Andrew after Gino's daughter Tosca passed away several years ago in San Jose.

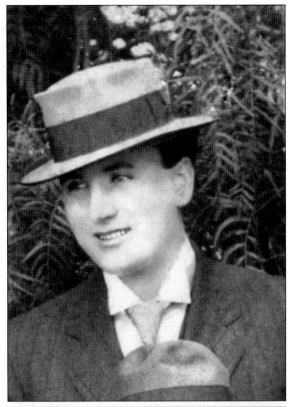

The compositional elements of this photograph, which was taken in San Francisco, are very reminiscent of Gino's photographic style. The photographer of this image has yet to be identified, but whoever it was obviously greatly influenced Gino Sbrana in his photographic compositions 20 years later. Gino is in the back row, center. This image was inherited and identified by Gino's nephew Andrew Brunetti.

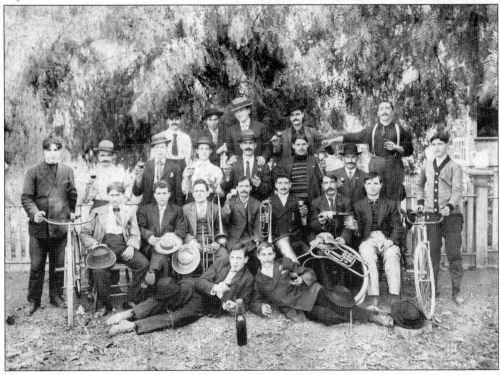

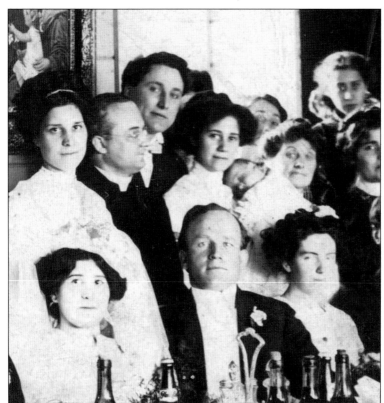

This close-up image of Gino came from the larger wedding photograph below. Marie is holding their first-born child, Dorothy. Sadly, Dorothy died not too long after this image was taken. The date would be approximately 1914, since Gino and Marie were married in 1913. Gino's nephew Andrew Brunetti identified this image and was the first to make mention of Dorothy.

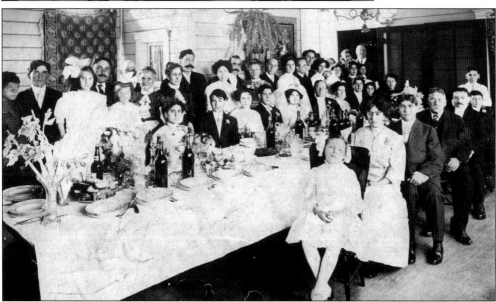

This c. 1914 celebration dinner in Oakland was for the wedding of Angelo Capelli and Rose Rubino, who was the sister of Marie Sbrana, Gino's wife. Angelo Capelli taught music at the University of Santa Clara. The groom can be seen above the girl sitting in the front, and his bride is to his right. Andrew Brunetti also identified Joe Arena, sitting fourth from the right with the gray mustache.

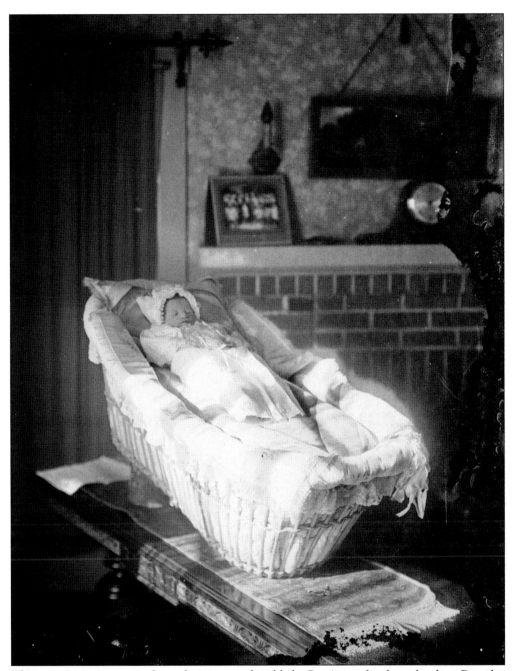

This post-mortem portrait of an infant is, more than likely, Gino's own first-born daughter, Dorothy. Andrew Brunetti did mention that Dorothy was buried in Oakland. Originally, this image was not going to be included, but after reading an article in *Artes De Mexico*, the author decided to include the photograph. Entitled "El Arte Ritual De La Muerte Nina," the piece discusses how a child's death is viewed as a life lived without sin; the child is considered an Angelito (small angel or cherub). Furthermore, the photograph is but a reflection of that eternal life to be lived as a saint, born upon the sacred plane, free of all eternal misery.

In 1988, Michel Allaire (in center, wearing "Staff" T-shirt) and the author created a hand-tinted photographic mural exhibition. The Sbrana exhibition (seen here) was shown at numerous San Francisco locations during 1989, including the Mills Building, Club Fugazi, Museo Italo Americano, and Festa Italiana (in 1989, 1990, and 1992). The exhibit was also shown at the Lost Coast Brewery (Eureka, 1990–1994) and Linguini's (Alameda, 1994–1998). Currently, Fernbridge Marketplace near Ferndale is hosting the exhibit.

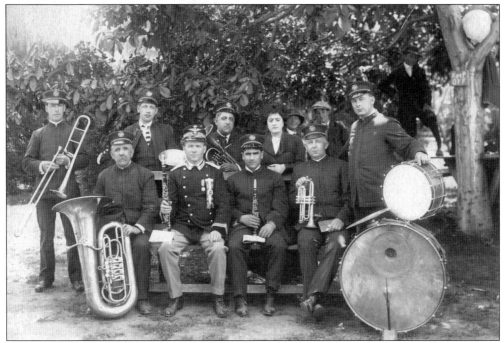

This is a c. 1915 photograph of the Angelo Capelli band of Oakland. Capelli was the husband of Rose Rubino, who was the sister of Marie Rubino Sbrana, Gino's wife. Angelo is sitting in the first row, second from the left, with the ribbon on his chest. This photograph is stamped "Pisa Studio, 533 Broadway, San Francisco."

Around 1989, the author went to the "Pisa Foto" building, rang the doorbell, and asked if any photographs or glass negatives had been found there. Surprisingly, this single postcard and several pieces of broken negatives had been discovered. There must have been thousands of "Pisa Studio" postcards and portraits made during the few years Pisa Foto was in existence.

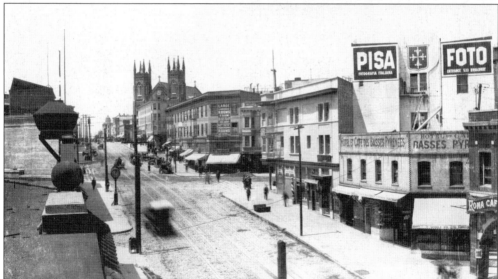

J. B. Monaco took this photograph from his studio location in approximately 1913. At the intersection of Columbus and Broadway, the location of Pisa Foto, founded by Gino and Carlo Sbrana, is clearly visible. Constructed c. 1910, the building can still be seen today in San Francisco, with its original north-facing angled skylights. Designed specifically for skylight portraiture, the structure may be the last of its kind in the United States.

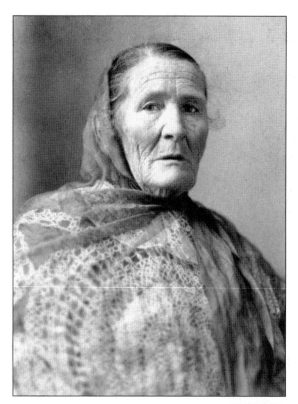

This is the mother of Gino Sbrana. The Sbrana family, including Gino, Carlo, Olinto, Giuseppe (father), and mother, emigrated to San Francisco from Pisa, Italy, around 1894. Not a single photograph has been discovered of the family together, nor of Carlo and Olinto. Very little is known about Gino Sbrana, and prior to publication of this volume, there was no mention of his existence on the Internet or in any book.

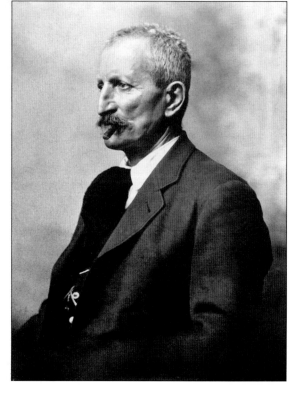

This is the father of Gino Sbrana, Giuseppe Sbrana. This image was inherited by Gino's nephew Andrew Brunetti after Gino's daughter, Tosca Sbrana Moran, passed away a few years ago. This image, stamped "Pisa Studio," was taken in San Francisco between 1913 and 1918. Gino rarely marked or stamped his later work, and this may be one of the contributing factors as to why there is no historical recollection of his photographs.

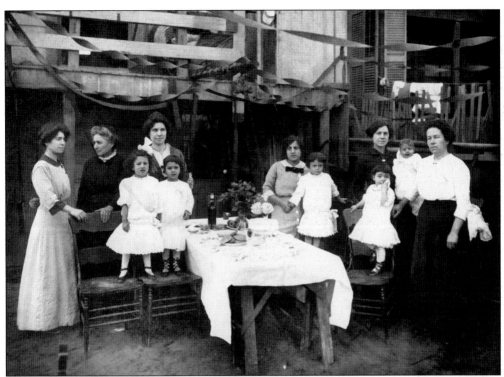

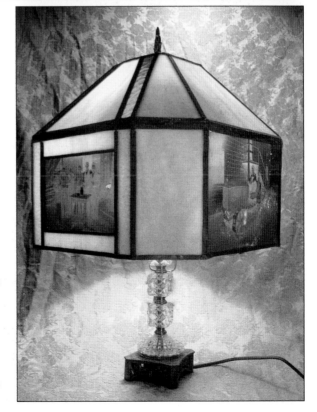

This birthday party is probably behind the Sbrana residence in Oakland, c. 1916. Marie Sbrana is second from the right (holding Tosca), and next to her on right is Maria Rubino (Joe Rubino's wife). At center, with black bow tie on, is Jenny Arena, with her daughter. Jeannette Sbrana is standing on the left with the white bow in her hair. Charles Rubino's wife, Marie Rubino, is second from the left.

This is a photograph (by author) of one of Betty Workman's 1970s lamps, made with Gino's negatives. Gino's wife, Marie, had originally wanted to donate the glass negatives to the University of Santa Clara, where Gino's brother, Olinto, was a professor. The university said it would be interested, as long as the Sbrana family paid for the insurance, which is why the negatives were left for all these years in the basement.

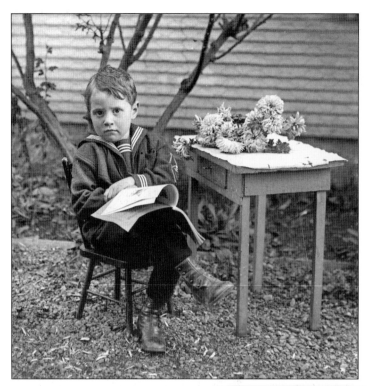

For nearly 20 years, this well-composed portrait of a young boy in a sailor suit sitting next to a flower-covered table was just one more unknown image in the Sbrana collection. However, earlier this year, Gino's nephew Andrew Brunetti, now 86, revealed that this image was actually of himself. The photograph was taken in San Jose around 1923.

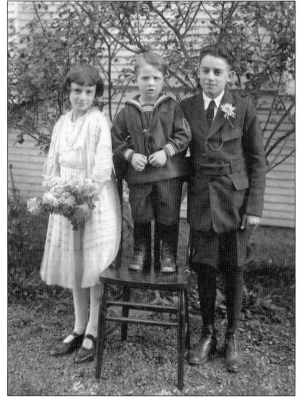

Jennie Rubino Brunetti was the mother of these three children, although the last name of the father of Irma and Phil was Antonuccio. Even as such, Phil will be referred to as Phil Brunetti. Since Andrew's father died shortly after he was born, Gino became like an adopted father to Irma (who later married Sam Piazza), Andrew, and Phil. Their older brother's name was Joe Antonuccio.

This confirmation photograph is of Gino's nephew Phil Brunetti. Andrew has told the author that it was his brother Phil who would go along with Uncle Gino to help assist in photographing the various doings and get-togethers at the ranches and farms around the San Francisco Bay.

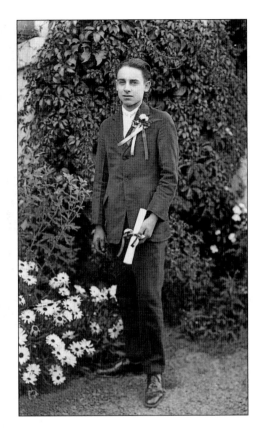

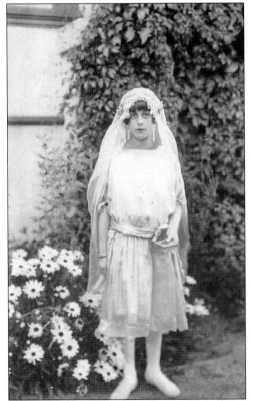

Andrew Brunetti recently identified this girl, in her first communion outfit holding a Bible, as being his cousin Tosca Sbrana. The details of Jeannette and Tosca's lives have not yet come to light. Neither of Gino's daughters had any children. Tosca lived her entire life in the Sbrana family house located in San Jose. Her husband's name was Wallace Moran.

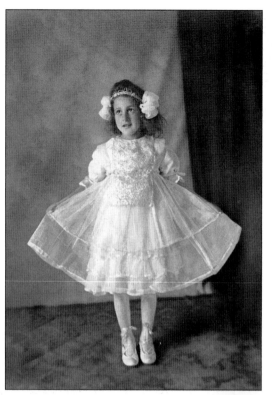

Andrew Brunetti tells stories of how he and cousin Tosca, seen here in this charming portrait, used to play together as kids . . . how she used to dress up in costumes and put on wild shows. Andrew said that he and Tosca used to play with the receipts from Pisa Studio, which were stored away at Uncle Gino's house.

Andrew Brunetti identified this *c.* 1928 image of himself in February 2006. Andrew speaks with much admiration about his Uncle Gino, recalling him as a very kind, wonderful, generous, and terrific man. Andrew refers to Gino as a romantic bohemian who would sing all day long while working in his darkroom. Andrew, who began chiseling granite and marble in the 1930s, has been the owner of California Monumental Company of San Jose for five decades.

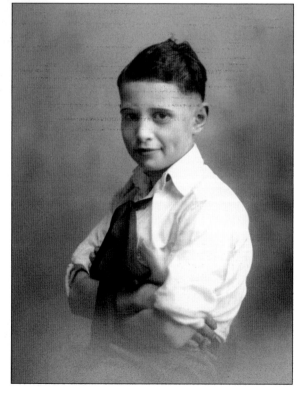

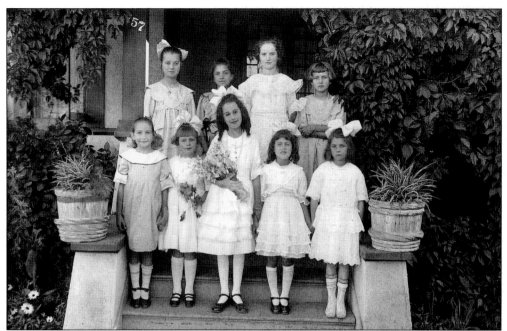

Marie and Gino Sbrana's house was located at 757 Locust Street in San Jose. Based on this information, the author has determined that this is a portrait of Gino's two daughters, along with some of their neighborhood friends. Jeannette is front and center, and Tosca is on her left. The seven other girls are unidentified. The date of this photograph would be approximately 1923.

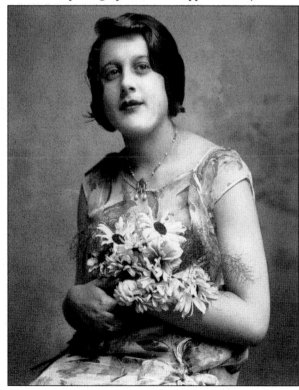

Andrew Brunetti, in February 2006, identified this young woman as Gino's daughter Tosca. This image indicates that Gino did continue photography on occasion after 1930. Andrew also stated that Gino may have also tried his hand at 35 mm photography in the 1930s, but these images have not turned up as of yet.

This old Methodist church (photograph by author) in Ferndale is where the story about the Sbrana photographs first began. A lady with an interest in making glass lamp shades stopped by to see the windows of the church. Luckily, the author's roommate, Paul Skofield, was there to answer the door. The glass negatives Betty "Mooga" Workman was turning into lamp shades turned out to be the lost and nearly forgotten Italian imagery featured in this book.

On New Year's Eve, 1925, Gino, Marie, Jennette, and Tosca Sbrana, along with Irma Brunetti, were leaving Oakland when a drunk driver crashed into Gino's Chevrolet. Marie received a broken arm, Jeannette was cut by broken glass, and Gino received internal chest injuries from the steering wheel. This accident was to eventually bring about the end to Gino's photographic career and singing ability.

Two

GROUPS

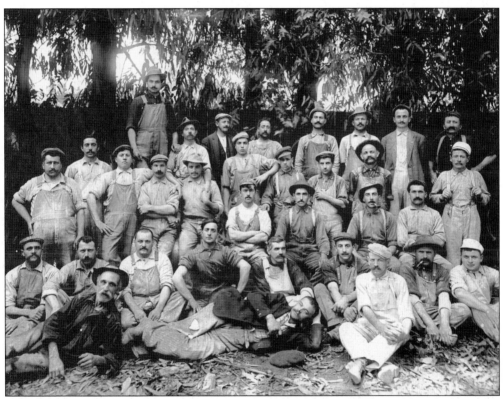

Although none of these 33 men have, as of yet, been identified, Andrew Caviglia of Alameda did believe this group to be East Bay scavenger workers. The early Alameda and Oakland Scavenger Companies employed a great many Italians. Thirty of these men are wearing overalls, the typical attire for this profession. Gino's ability to find soft lighting conditions, such as here for this large group photograph, will be evidenced throughout this book. The date of this image could be anywhere from 1915 to 1925. Italians were not known to have their photographs taken very often, either in studios or by home portraiture, meaning, these images reveal the faces of countless Italians who were possibly never photographed before.

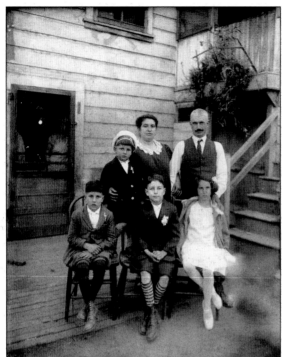

The little boy in the U.S. Navy sailor suit is Al Lanza. Al was the first person to begin identifying people in this collection when these images were first shown at the large Gino Sbrana exhibition at Festa Italiana in San Francisco. Pictured here, from left to right, are (first row) Aldo, Elbi, Eldo, and Alga Lanza of Colma; (second row) Julia (mom) and Secondo (dad).

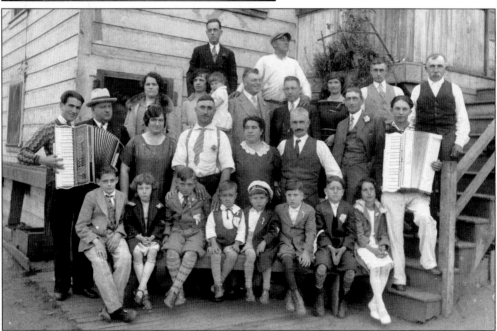

This Colma group includes, from left to right, (first row) Tino and Tina, Guido and Citero Barbano, then Elbi (Al), Eldo (Mike), Aldo, and Alga Lanza; (second row) unidentified (with accordion), Canuaso (who taught Dick Cantino accordion, according to Al Lanza), Anthony Barbano's wife, Anthony, Julia, and Secondo Lanza, and Louie A. Garaventa (with accordion); (third row) the wife of Tony Falia, Dorothy and child, Sam, unidentified, Lydia, Peppin, and Martino; (fourth row) Mike and Tony Falia.

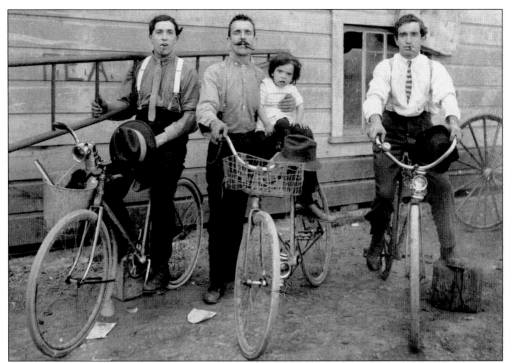

This photograph of Pietro and Tomaso Franco (both at left) was shown in the East Bay in an exhibit of photography entitled Con le Nostre Mani in 2004. Though the organizers did not know it, this image actually came from one of Gino's negatives. These three men worked as window washers for Lavavedri of Oakland.

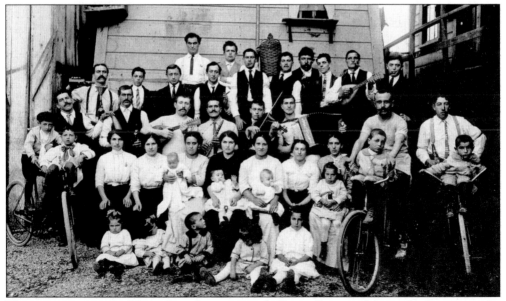

The young man on the bike at far right appears to be Pietro Franco, who can also be seen on the left in the above photograph. In this Oakland, c. 1917 image are babies, children, fathers, mothers, musicians, three bicycles, an accordion, two mandolins, a clarinet, a violin, vino, two bottles of Yosemite beer, a baguette, cigars, and many friends, all in front of a water tower.

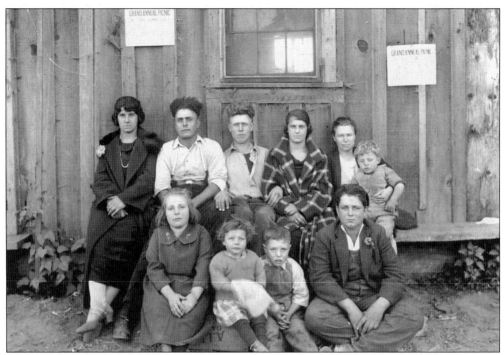

This photograph was taken in Contra Costa County at the Grand Annual Picnic. The poster reads "Cristoforo Colombo Society, Oakland, Sunday May 25th, 1924." This group from Alameda includes Marcello Siri (second from left, second row), Clara Ratto, Giovanni Siri (third from left, second row), Lala Ratto, Ben (little boy), Catarina Callela, Gambado (Bocci), and Teresa and Catarina Ratto. This photograph was identified by Tony Ratto.

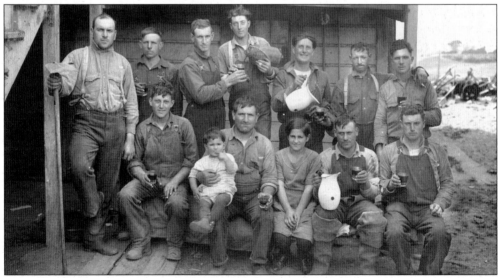

This 1920s group photograph of young vegetable workers was taken in Colma. Identified by Al Lanza, in no particular order, are Eugenio Delbono, Tony Ciarlo, George, Lina Ciarlo, Lungo (tall one pouring vino), and Savori and Jack Accenelli. The others are unidentified. These images reflect a wonderfully comprehensive cross-section of the entire Italian community, including some of the poorest and hardest-working Italians of the San Francisco Bay Area.

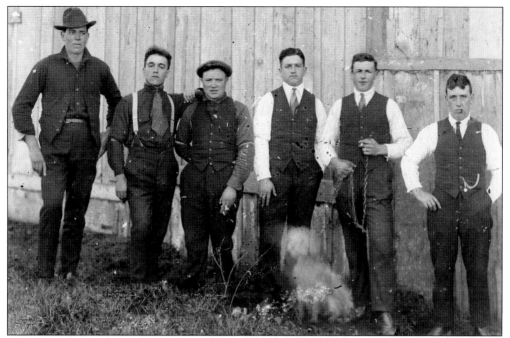

Many of the images in this book have never before been published or seen. This is an interesting group, included here in hopes that someone will eventually identify their dad or cousin or grandfather. What also makes this image memorable, other than the giant Italian on the left, is the appearance of the ghost poodle on a chain.

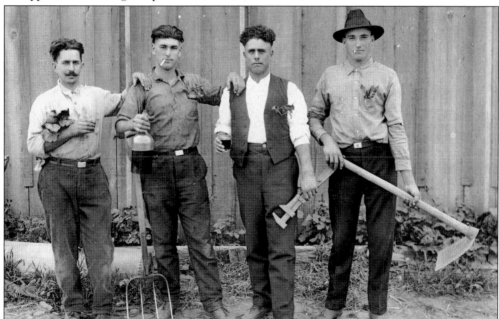

Also featured in this photograph of four men are a large hoe, a wrench, a pitchfork, a bottle and two glasses of vino, a beet, and decorative leaves of some sort in each of their shirt pockets. The man holding the wrench is a Siri, but whether Giovanni, Giuseppe, or Marcello, is undetermined. This Siri does look a lot like Marcello Siri pictured on page 89.

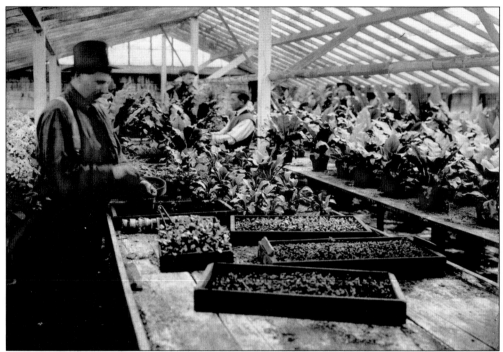

Here Caesar Restani works in a large greenhouse located somewhere in South San Francisco. This image was identified by Caesar's grandsons and Bianca Hoffman Restani. Note the flowers behind Caesar. Many of the early Italian vegetable farmers eventually switched over to cut flowers grown in greenhouses.

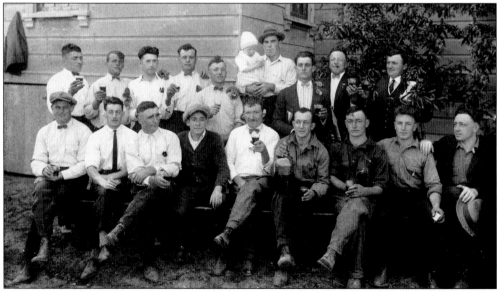

The owner of the Richmond Scavenger Company can be seen in the front row on the far left. Also in this photograph are Meneghia Craviotto (first row, second from left), Attilio Craviotto (second row, third from left), Anthony Freccero (holding baby Angelo), Pettini, Pallegro Caviglia, Manuel and Pietro Perata, Joe, Cecconi (Pellegro), and Pietro and Pete Perata. Andrew Caviglia identified this 1922 Alameda image in 1992.

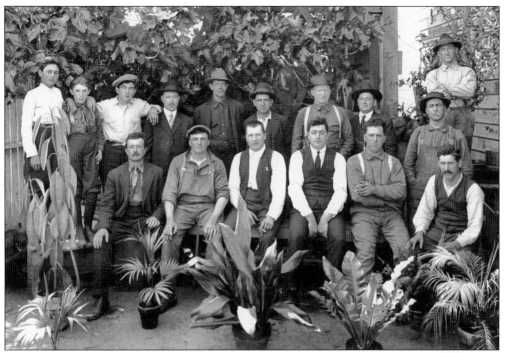

Gino, with an eye toward always enhancing the appeal of his imagery, has added six large potted plants in the foreground. The man in the white shirt and open vest in the front row can also be seen behind the wheel of a Cotella Bay Farm Island truck on page 70. This one clue is what suggests this group is from Bay Farm Island, photographed *c.* 1924.

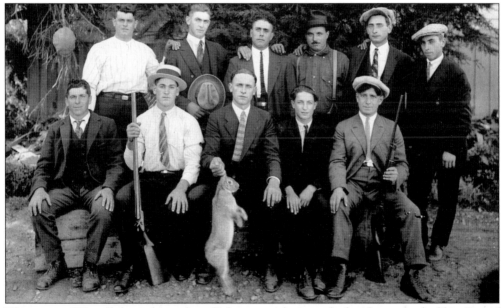

This group of 11 well-dressed men from Colma were photographed with one dead rabbit. One of the Siri brothers can be seen third from the left in the second row. Apparently, the Siri brothers (of Colma) are not immediately related to the other Siri brothers who farmed up near the Cow Palace, at least according to Frank Siri, who is 91 . . . and still gardening.

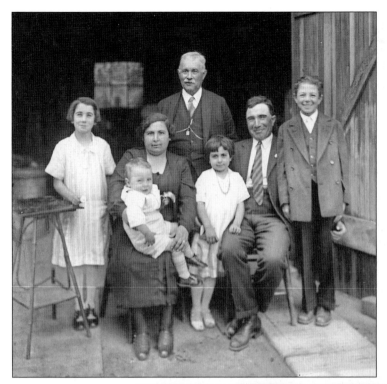

In case it was thought that everyone was too stiff, stoic, or stern back in the old days to crack a smile, well, this photograph proves otherwise. Maybe Gino left this portrait up to his 10-year-old assistant, Phil Brunetti. Whatever the case, this unidentified family of seven is all smiles.

Once again, one can see how Gino has taken his time to compose and balance the various elements: the four men in suits, the vino, and the puppy (behind the bottle of vino). The location and the names of these well-dressed men are still waiting to be identified.

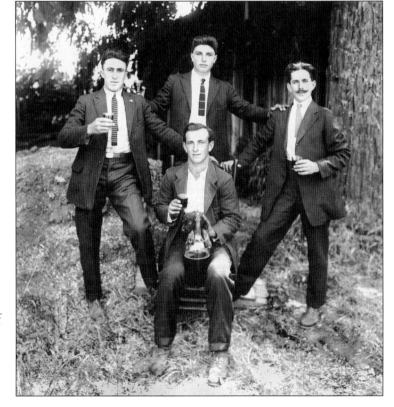

34

This is another Colma photograph Al Lanza was very excited to find and identify in the Sbrana collection at the 1990 Festa Italiana. This is an early 1920s portrait of Anthony Barbano, his wife, and two boys, Guido and Citero. The Lanza and the Barbano families are relatives of one another and can be seen together in the group photograph on page 28.

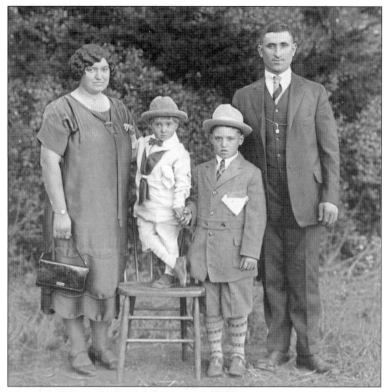

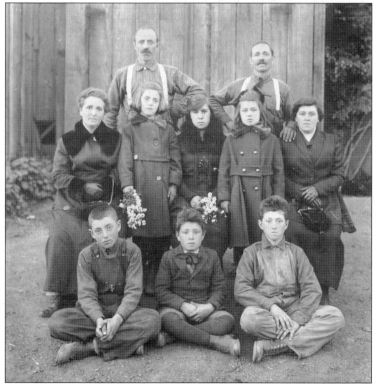

How could someone so admired in the Italian community, who was so prolific at documenting the Italian community, become so completely forgotten in history? Maybe it was the fact that he specialized in traveling to all parts of the Bay Area, maybe it was the fact he never stamped all of his works, or, possibly his talents were only known by word of mouth.

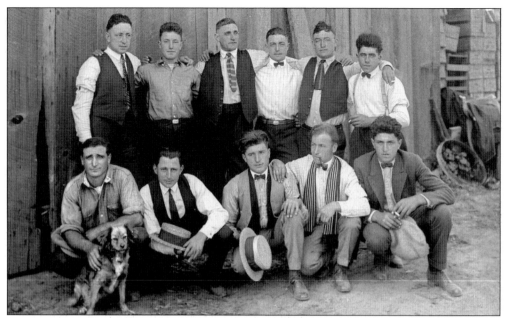

The young men in this Alameda photograph include Joe Cerruti (third from left, second row), Pete Cecconi, Carlo Orselli, Andrew Caviglia (second from left, second row), Bocci Caviglia (second from right, second row), Pete Ratto, Bocci Ratto (first row on right), Anthony Ratto (second from right, first row), Pete Perata, John Perata, and Pete. Andrew Caviglia, Rose Vallerga, and Albina and Yolanda Tesconi helped to identify this photograph.

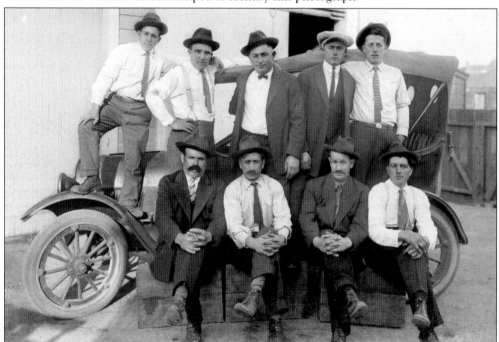

Andrew Caviglia of Alameda identified two of these nine men as being Tony Vallerga and Perodi. The young man standing second from the right can also be seen on page 58 in the bottom photograph and on page 83 in the top photograph.

Though these photographs may have been taken during Prohibition (1920–1933), the Italians of the San Francisco Bay Area were not going to be deterred by the new law, especially in regard to their love of vino.

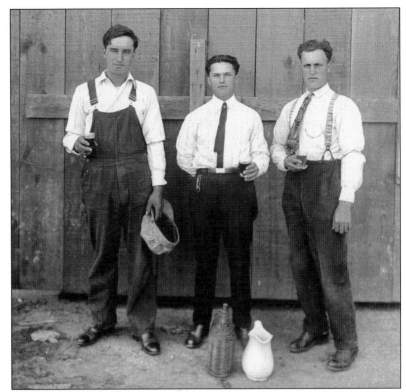

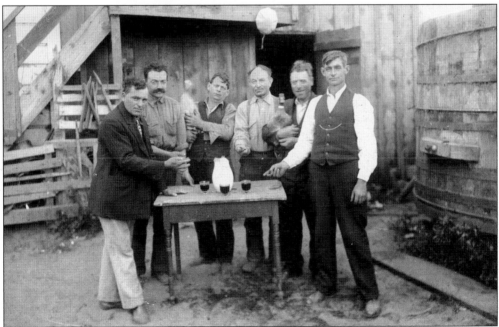

Several people have identified this photograph to be of men playing the game of Mura. According to Frank Siri, the hands of the participants move quickly, with each hand revealing a number of fingers. This could be played as a drinking or betting game or just for fun. With a vat of wine at hand, as pictured in this early 1920s image, the results are more than predictable.

Gino rarely stayed in his portrait studio on Locust Street in San Jose to do portraits and much preferred on-location portraiture. In-studio work usually involved family members. Gino exposed three separate glass plate negatives of this unidentified family of three.

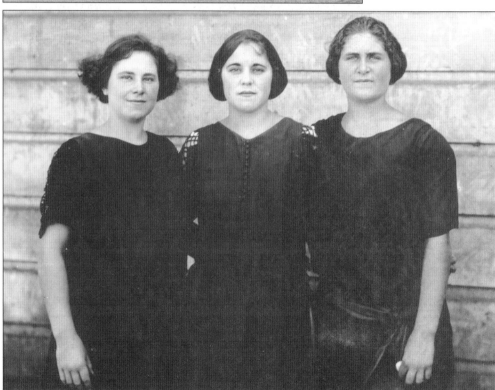

The photographic record of the Italian community left by Gino Sbrana is one mostly of men—men and trucks, men and tools, men and vino, men and horses, men and cars, men and motorcycles, and so on. As for the women and children he did photograph, plenty of these images are included in this book. These three women, c. 1920, have not yet been identified.

How this simple image could possess such timeless enchantment is a question worthy of pondering by many modern photographers. Soft lighting is all-important in portraiture. However, there is another integral element of Gino's technique, which is the shallow depth of field. This sharp focal plane is primarily located around the faces, which, in turn, naturally draws the viewer's attention to that area, while all else remains diffused.

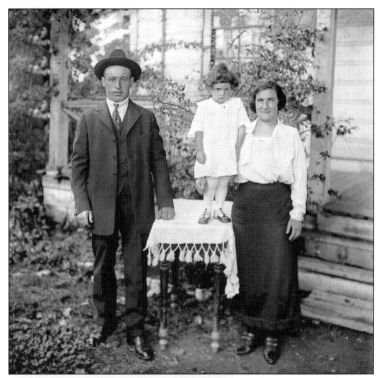

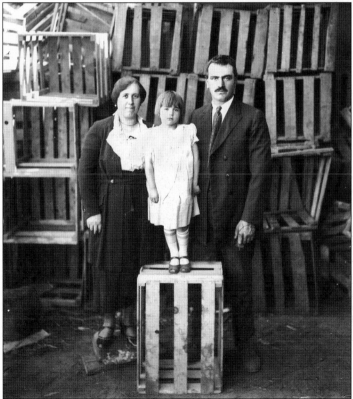

Gino gives first consideration to lighting conditions. This on-location randomness, based on available light, leads to rather interesting and unusual backgrounds, at times. Wooden vegetable crates serve as a backdrop for this portrait of the Bordi family (of San Francisco). Pictured, from left to right, are Peppina (mom), Edith, and Attilio. This photograph was identified by Peppina's son Richard Bordi.

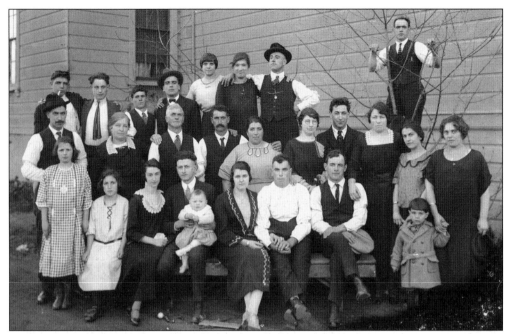

This Alameda group includes, from left to right, (first row) Edith Perata, Emma Perata, Teresa Perata, Benny Perata (holding Bernie), Angelina Freccero, Anthony Freccero, Joe Bolla, and Joey (young boy); (second row) Steve Freccero, Frances Perata, Sebastian Perata, Johnny Perata and wife Mary Rossi, Tony Rossi, Kay Bolla, Delvina Perata, and Eleanor Calcango; (third row) Joe Perata and Pete Canepa. Also in the third row is Julia and Bocci Cipresso (tallest). This photograph was identified by Joann Freccero.

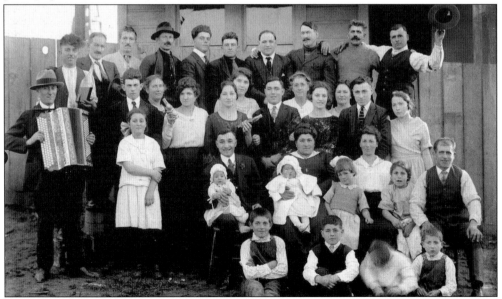

This group was determined to be from Colma, based on the Joe Anguillo identification of the Cipresso family photograph on page 96. George Cipresso is behind the girl in the white, and Mary is next to him holding up the bottle of beer. The other 33 people in this photograph are waiting to be identified.

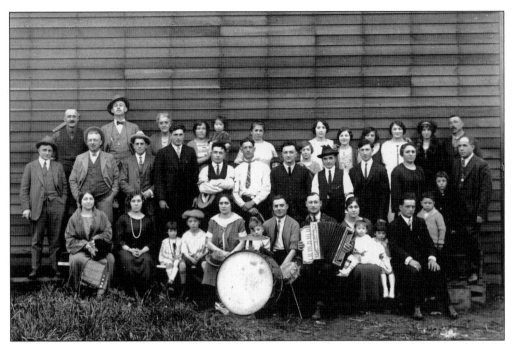

This community or family gathering of 37 people is at an unidentified location. So far, only Orlando Disperati (wearing a vest, standing behind the man with the accordion) has been identified. Hopefully, one of the younger people pictured here will pick up this book and recognize this image someday.

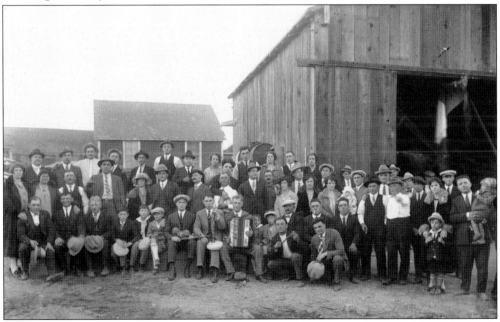

This large group with musicians is said to be posing together in Colma. So far, the only people identified are Vittori and Amelio Cervello, the twins sitting behind the man with the diagonally striped tie. At these types of gatherings, Gino would photograph the festivities and, according to nephew Andrew Brunetti, stay for hours singing opera.

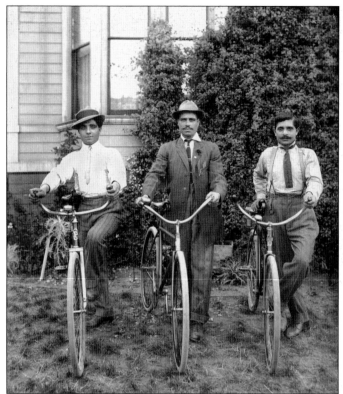

The fob hanging from the waist of the man on the right reads 1915, while on his tie can be seen many swastikas. The negative, from which this photograph originated, is amazingly detailed and once again, as in most all of Gino's work, the lighting is perfectly suitable to portraiture. The location and the names of these men have not yet been determined.

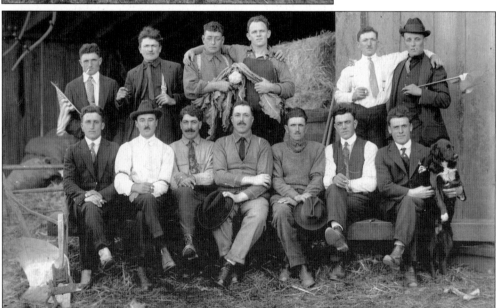

Marilyn Olcese was the first to identify this Colma photograph, finding her grandfather, Giuseppe Gaggero, who is holding the cauliflower (at left). The first row includes, in no particular order, Jimmy Garibaldi, Charlie Nan, Angelo Nan, Batolomeo Ratto, Nicola Ratto, Cente, and unidentified. In the second row, from left to right, are Adolfo Gonella, Boccia, Giuseppe Gaggero, Pala Vicino, unidentified, and Amadeo Gonella.

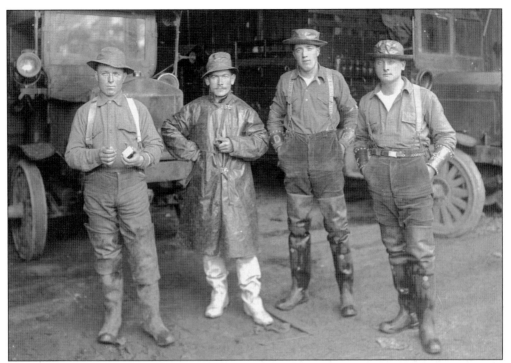

There has been much speculation as to these men's profession. Since they are dressed very similarly to the cauliflower harvester seen on page 47, they may also be vegetable farmers looking to stay dry in the damp coastal fog that often hugs the hills of the San Francisco peninsula. One set of cuffs has the initials "G. D." (man second from right). One of these men was identified as possibly being Antonio Ratto.

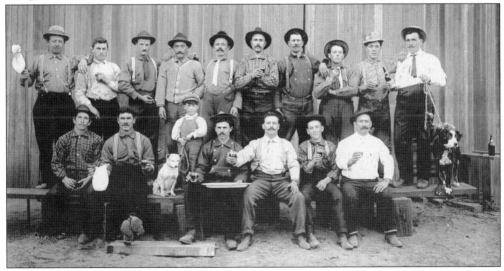

This image was enlarged to eight feet, with no visual evidence of film grain. The four-foot-by-eight-foot enlargement, which was hand-tinted by Michel Allaire, has been on display at the Lost Coast Brewery in Eureka since 1990. The only two people identified are Giacomo Aveggio and Ettore Repetto. This image, taken in Colma at the Apollo ranch, was identified by Lois Rosano Aveggio.

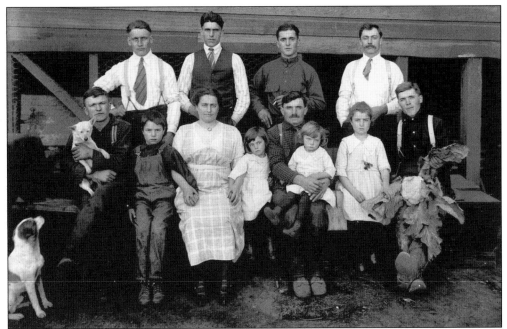

The little girl on the right is Elsie Pollastrini, who, 70 years later, identified this *c.* 1921 photograph. This Westlake photograph features Paolina (mom), Marie, Rose, Elsie, Giuseppe and Amadeo Demegrasso, Gogna, Danielle Couson, and Louis. This group can also be seen out in the cauliflower fields on page 86, and Elsie can be seen also on page 95.

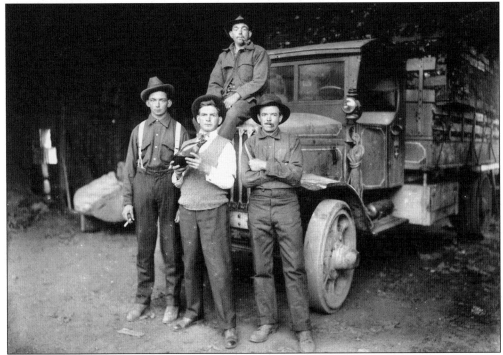

Vino was more than welcomed in a lifestyle in which an 18-hour workday was commonplace. Four unidentified men from Colma pose in front of a vegetable truck, holding a large bottle of wine.

Here Gino has photographed a bride and groom with their maid of honor and best man. This photograph has not been identified as of yet. The porch in this image is very similar to the one in the photograph below. This bridegroom is also on page 59, sharing a glass of wine with the gentleman in the bottom image.

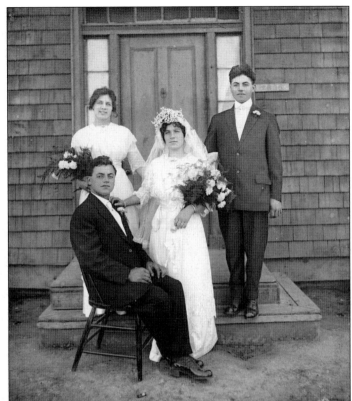

This front porch family portrait shows once again the compositional balance that often characterizes Gino's portrait work. This may be the father of the bride seen in the image above, since one of the girls in this image does look like the bride.

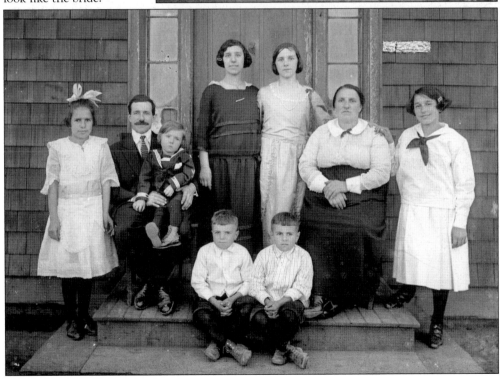

From left to right are Mary, Catarina, Emilio, and Albina Garibaldi at their house in Colma. A typical day for Catarina at this time period included feeding 20 people three meals a day (family and 16 farm partners), chopping wood, doing laundry, milking cows, and, in her spare time, tending to the vegetables. This photograph was identified by Mary Garibaldi, whom the author met in 1992.

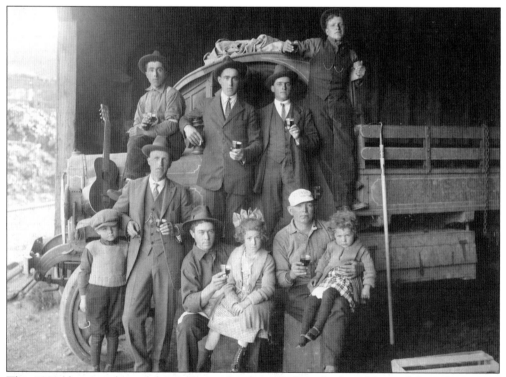

This 1922 photograph is of the Pastorino family, including Andrea. None of the other names have been identified yet, and there has been no determination if these Pastorinos are related to Geranina Pastorino, who is the mother of Sam Vallerga (see page 52). The side of this pin-striped truck advertises "A. Giusto."

Three

INDIVIDUALS

The large, wooden camera that Gino used was a full-plate 6.5-inch by 8.5-inch field camera. These large-format negatives preserved with extraordinary resolution and detail the beautiful imagery seen throughout this book. Here is a wonderful example of the power of photography to capture a moment in time here on Earth, which, once seen, shall never be forgotten. The farmer in rain gear, the positioning of the machete, the stare, the cauliflower, the fog, and the angle of view all contribute to this timeless image. This photograph has long been one of Gino's most popular and admired images. This person was identified as possibly being "Parma" of Colma.

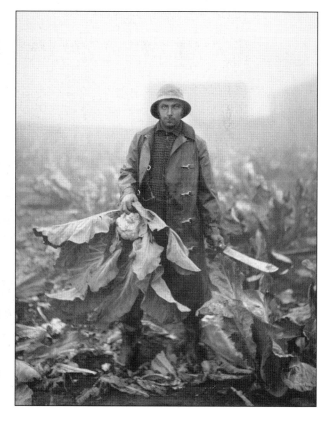

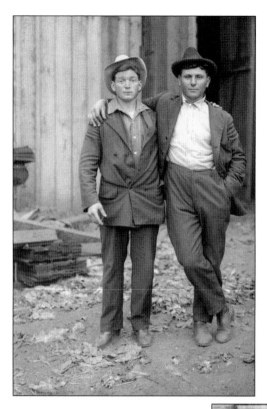

Even Gino's most straightforward portraits somehow possessed a timeless simplicity and appeal beyond words. This honest, yet unaffected sincerity of portraiture is apparent throughout Gino's photographic work.

This San Francisco *La Voce del Popolo* newspaper reads, "Hanno Sequestrate 300 Casse di Whisky." A little research shows that this paper was in existence from 1868 to 1931, and since the headlines are talking about a Prohibition raid, the date would be likely in the early 1920s. This young man in a black suit and bow tie has not yet been identified.

It is difficult to say what Gino's original intent was here in this fascinating and unusual photograph. Sometimes there would be opaque ink painted around the face. Presumably this was done so that the image could be cropped to make a smaller, passport type of photograph. However, in this case, the touched-up emulsion ends up making the unidentified man look like he has wings.

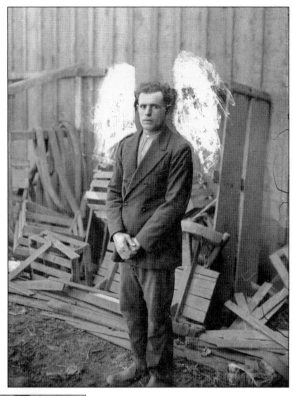

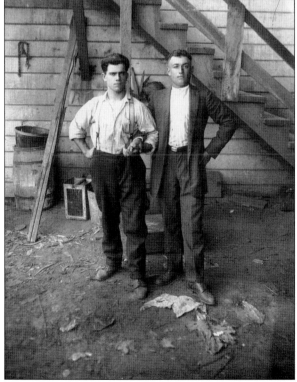

Gino's reverence for the Italian community was conducive to an ambience of integrity and respect observable throughout his portrait work. Rather than being detached from his subjects as other professional photographers were, he was one of them.

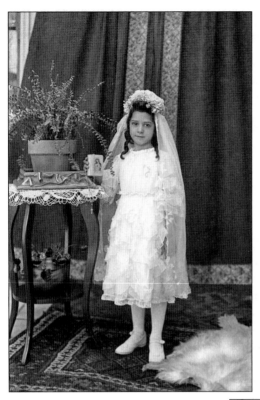

This First Communion image of a young girl is a superb example of Gino's ability as a portrait photographer. Included in the composition are velvet curtains, a sheepskin rug, a fern in a clay pot, a small parlor-style table, white lace, a Persian rug, a flower-decorated long white veil, a small Bible with rosary beads, and a beautiful white dress.

This First Communion photograph of two of the four Lanza children was taken on the same day as the Colma group photograph seen on page 28. The 1990 Festa Italiana in San Francisco is where Al (Elbi) Lanza began to identify many of these images of Gino Sbrana, including this one of his brother Eldo and his sister Alga.

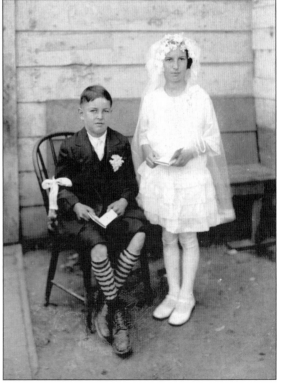

More than likely, this First Communion photograph was taken in Gino's backyard portrait studio at 757 Locust Street in San Jose. To capture his subject, Gino only took one single exposure 98 percent of the time. In these days of bracketing and multiple exposures (with film cameras and digital cameras), he would be regarded as a master of light and photographic composition.

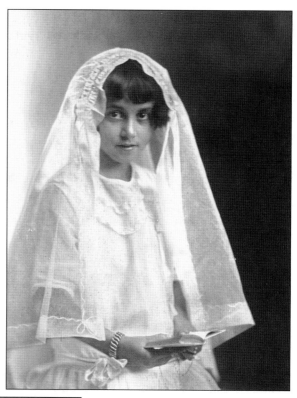

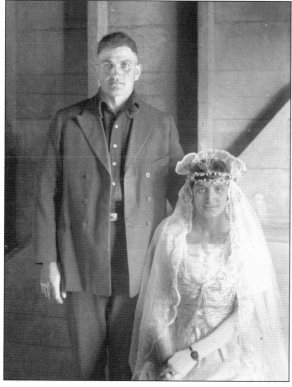

This unidentified photograph of a bride and groom in a barn has amused, for various reasons, many people over the years.

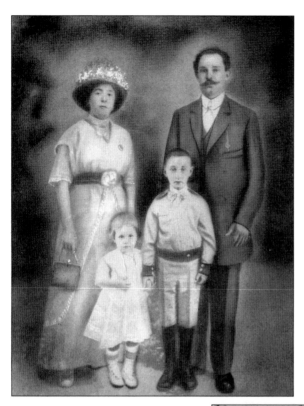

Diane Sottile, daughter of Sam Vallerga (see page 80), showed the author this enlarged (colored) photograph of her dad as a young boy, which was said by Sam's wife Rose to be a composite of two images. Sam's mother died when his sister was an infant, and this is why Gino combined the two images of Sam and Catherina along with Geranina and Giovanni to make one photograph of the family together.

This is a copy of a photograph Gino took of a preexisting image that turned out to be Sam's mother and father, Geranina-Pastorino and Giovanni Vallerga. This is one of the two images that Gino used to make the composite above. Sam's uncles on his mom's side were Jack, Nick, Jimmy, and Joe Pastorino.

This is a *c.* 1916 portrait of Sam and Catherina Vallerga taken in Alameda—the other photograph that Gino used to make the composite family portrait on the opposite page. Sam was born in Napa. Due to the unfortunate death of his mother shortly after his sister was born, he and his sister moved to Alameda to be raised by their grandmother, Antoinette Perata.

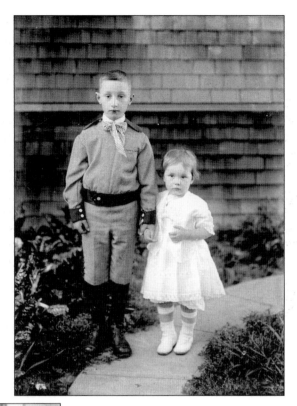

This photograph of Antoinette Perata, grandmother of Sam Vallerga, was taken in Alameda. Until recently, Sam's daughter Diane Sottile had no photographs of her father from when he was younger. Now, all of a sudden, five images have shown up so far from Gino's collection, and just recently this one came to light of Diane's great-grandmother.

This image, along with the other hundreds of identified and unidentified Italian glass plate negatives found in the collection, represent possibly the definitive visual record of an Italian culture that contributed significantly and mightily to the well-being and development of this San Francisco Bay Area Region.

Time and time again, Gino's rather straightforward portraiture has resulted in an unaffected exquisiteness of imagery seldom seen in camera work of any era. These Sbrana images represent a rare reflection of an Italian era long gone, which, up till now, has only been read about. This c. 1920 portrait is of Gianni Battista Ferro of Alameda.

This is one of a handful of portraits Gino made of just women. The date is unknown, but the dresses appear to be from the 1920s.

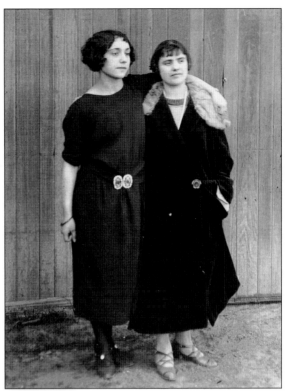

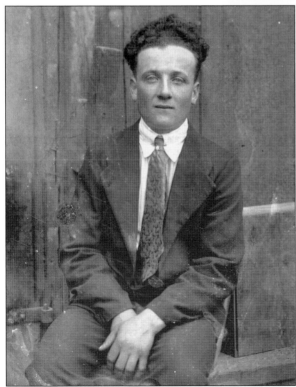

This is a portrait of young Amadeo Gonella of Colma. He can also be seen holding the flag of Italy on page 42. Amadeo is the father of Floyd Gonella, who was the superintendent of San Mateo schools for years. The author met Amadeo in 1992 in Colma.

In the image above, mom looks lovingly on as her young son sits for possibly his first portrait. Below, dad is ready to lend a helping hand as his young sailor son stands for his first portrait. Italians in the 1920s did not readily adopt the use of box or pocket cameras, and therefore not many photographs have survived portraying the Italian community of the era. This is another reason Gino's imagery is quite unique, not only for his techniques, but also for the rarity of subject matter and era depicted.

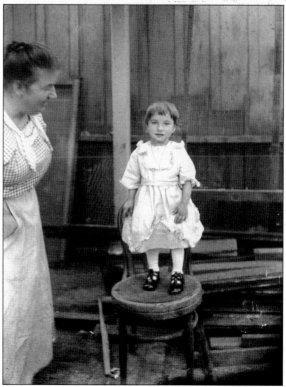

Gino was a photographer well versed in studio portrait work. Along with brother Carlo, he founded a large photographic establishment in San Francisco at Columbus and Broadway (Pisa Foto) where angled skylights, props, painted backdrops, and other conveniences were always at hand. Even so, probably none of those portraits ever had the spontaneous and intrinsic appeal as the four images on these two pages.

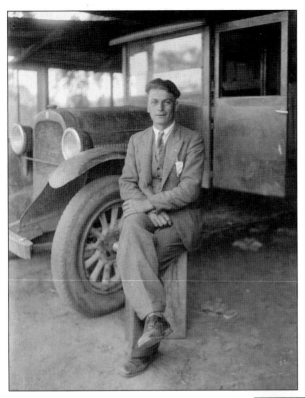

Chapter seven of this book features images in which white reflector cloths were held up to bounce light and soften the contrast. The open door on this truck is probably serving the exact same purpose. As can be seen often in Gino's down-on-the-farm imagery, the barn was the environment best suited for soft-light portrait work.

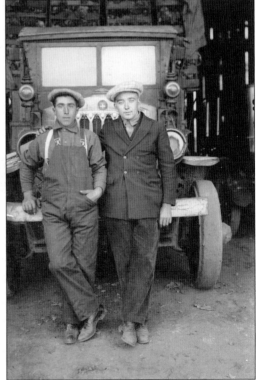

The young man on the right appears to be the same man with the plow and horses in the photograph at the top of page 83. The flag emblem of Italy is clearly visible on the front of the truck.

The Italian community's admiration for Gino's talents, in conjunction with a certain kinship of Italian spirit, obviously negated any reservations they may have had relative to the prohibition of alcohol from 1920 to 1933. As indicated in these two photographs, vino continued on as both an admirable and desirable pursuit that the Italian community freely allowed Gino to photograph.

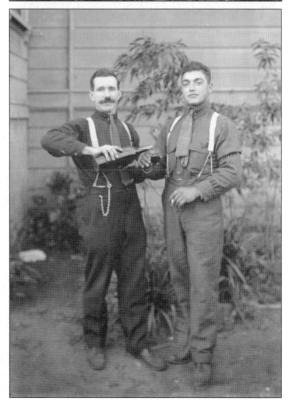

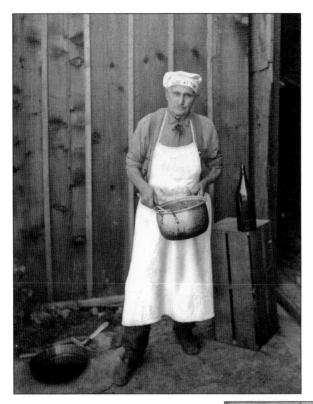

This photograph from Alameda, of an unidentified cook with the tools of his trade (including a frying pan, large soup pot, spoon, apron, "Bakers A-1 Flour" hat, and a bottle of vino) has long been one of Gino's most requested images. The wooden crate is labeled "Sunkist Oranges." This cook is also posing in the group photograph on page 67.

This is a 1986 graphite pencil and ballpoint pen drawing by Carlos Bowden Jr. of one of Gino's images. In the original drawing, the couple measures approximately seven inches high. This author has been drawing his entire life and is also known as Chuck Bowden.

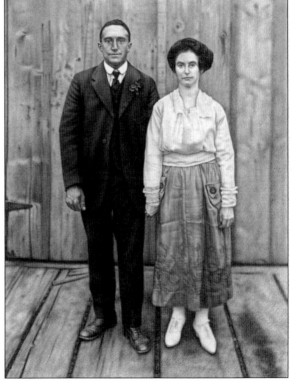

Gino went out of his way to gather together a comprehensive photographic study of Bay Area Italians. This butcher, holding both a large rooster and rabbit, has not yet been identified.

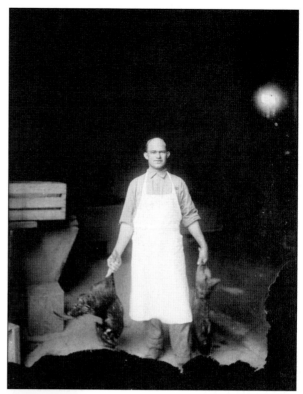

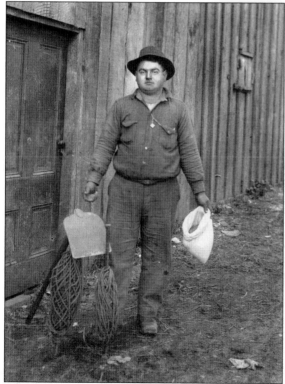

This young man, carrying a large hoe, rope, and bag of seeds, greatly resembles Silvio Landini of Colma, who can be seen on page 64. Silvio would go on to become the very popular chief constable of Colma. He was also popular as the local Paul Revere, who, upon hearing that the Prohibition troops were on their way, would drive around the countryside forewarning the moonshiners and bootleggers that the "Prohis" (federal agents) were coming.

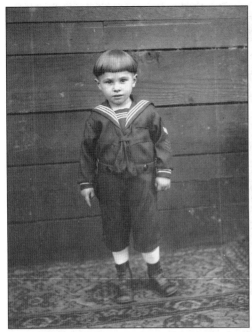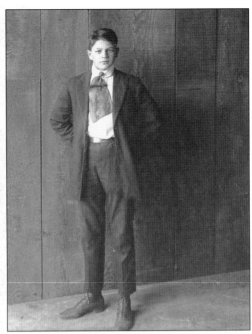

Many of these portraits were taken just after World War I ended, and dressing young boys in sailor suits, such as the one pictured here in the above left image, seemed to be quite popular. The author imagines that many of the children seen in this book are still living somewhere around the Bay Area. Won't it be a surprise when they pick this book up?

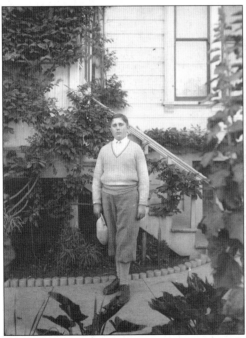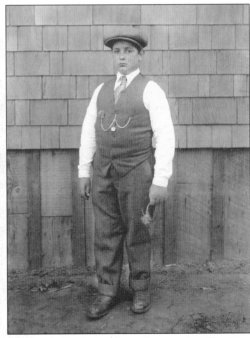

Although most of Gino's images seem to be taken down on the farm or ranch, occasionally Gino would venture elsewhere, as is suggested in the photograph on the left. In the entire Gino Sbrana collection, there are only a handful of images in close proximity to a city.

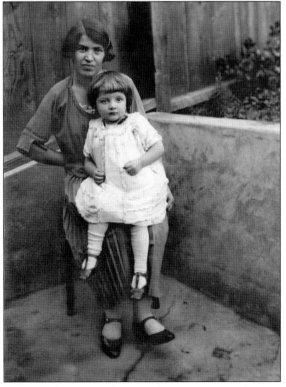

About 99 percent of the portraits Gino did were of Italians. These two photographs, along with the first image of chapter eight, are the exceptions to the rule. The image above is one of the rare instances of someone of African descent appearing in the 600-plus images taken by Gino. Below, the young girl in white and the woman wearing the pleated skirt had two pictures taken of them on this day. None of these people are identified, and hopefully, that will change once the Sbrana imagery finally becomes available.

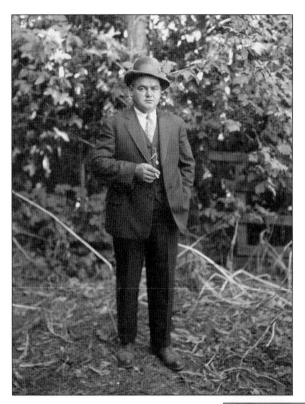

Elected as the constable of Colma in 1915, Silvio Landini quickly became a hero during Prohibition. Whenever raids were to be conducted, Silvio made sure he personally forewarned the potential offenders. Colma believed that the making of wine was an inalienable right. Regardless of Prohibition laws, more than 1,000 gallons of wine a day were supplied to San Francisco.

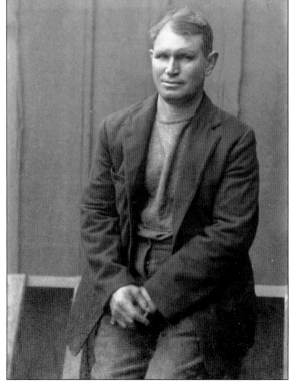

This portrait is of young Johnny Rivera of Colma. The 1992 fall issue of *La Peninsula* (published by the San Mateo Historical Association) was dedicated almost entirely to the imagery of Gino Sbrana and to the stories of those people whom Gino photographed around the Colma area. A photograph of Johnny Rivera, along with recollections and stories about his life, were featured in this 1992 issue. Michael Svanevik and Shirley Burgett contributed excellent articles.

In San Mateo, Ambrosia and Giuseppina Guastavino used to make vino during Prohibition. One time the notice came in late that the "Prohis" were on their way, and all was hidden away except one barrel. When the agents raided the premises, nothing was found though. There stood Giuseppina, with an "I don't speak no English" look on her face, while her dress concealed the illegal barrel of vino on which she sat. This story comes from Joe Lencioni.

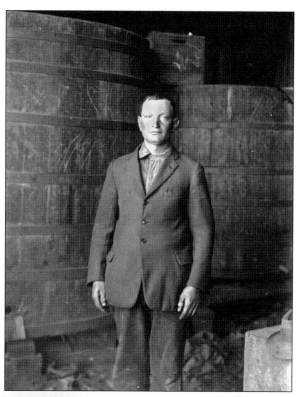

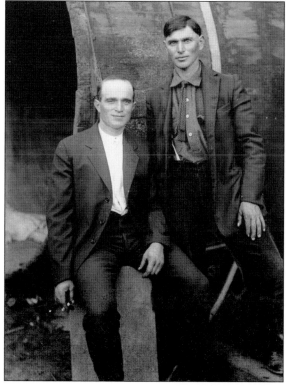

This portrait of two unidentified gentlemen was taken in front of an extremely large oak wine barrel. Drinking vino was an inalienable right (according to most Italians).

Even the simplest of Gino's portrait work resonates with character galore. This wonderful image, of an unidentified boy sitting on a vegetable crate with his dog, is remarkably captivating for its simplicity.

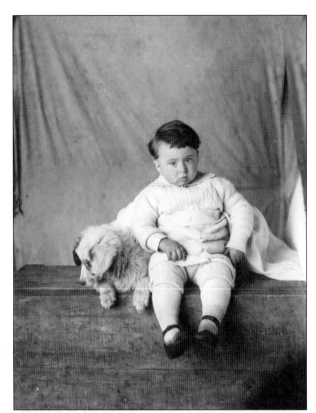

This amusing photograph of a naked baby, with a maid and perhaps the child's mom holding up a dark blanket (for contrast), has always been one of the most popular images in Gino's collection. Most likely this photograph dates from between 1918 and 1922. This baby and the people seen here are still waiting to be identified.

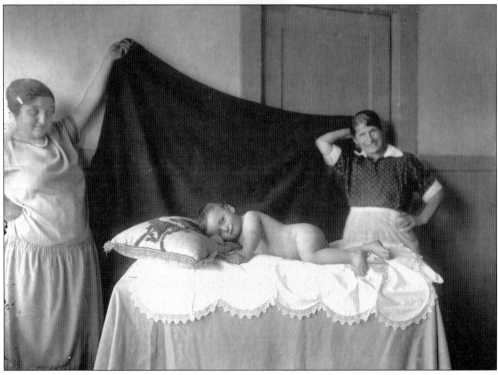

Four

TRUCKS

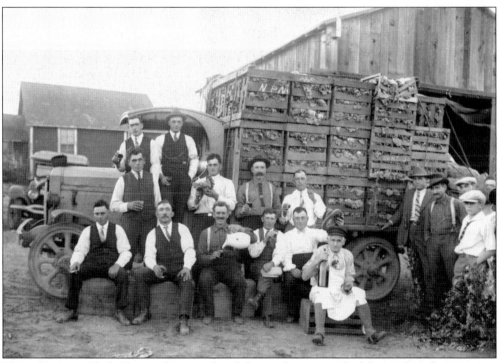

Once the vegetable fields were harvested and the trucks were readied for market, the men were more than ready to celebrate with a little vino. Gino took another photograph on this day in Colma (see page 41). These types of harvest celebrations are where Gino would, once the business of photographing was done, join in the festivities by singing opera upon request.

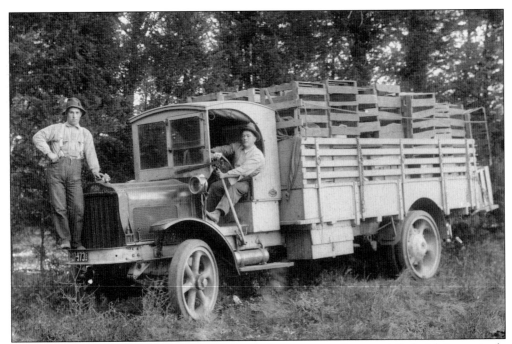

As evident in the two photographs on this page, Gino was not always satisfied with just a single photographic representation of his subject matter. This three-quarter angled profile of a 1920 produce truck was Gino's usual choice to best represent fully the story of these truck farmers and their loads.

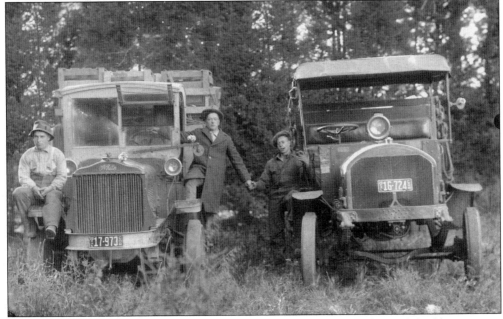

Sometimes these trucks did not even have front windshields or headlights. Solid-rubber tires, no doors, and hand-crank starters may seem today rather impractical and burdensome, but compared to the grueling loads these Italian farmers already had to endure, these trucks were a grand and welcome step up in the evolution of farming around the San Francisco Bay.

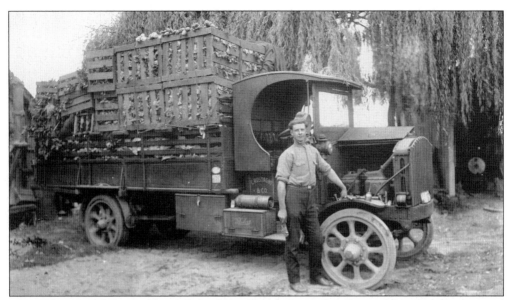

This early 1920s Kleiber truck is fully loaded and ready for market. Some of the vegetables pictured include turnips, potatoes, lettuce, and cauliflower. The side of this truck reads "C. Rostagno and Co." This unidentified truck farmer, with wrench in hand, appears to be making a few last-minute engine adjustments before heading off to the Colombo Wholesale Produce District.

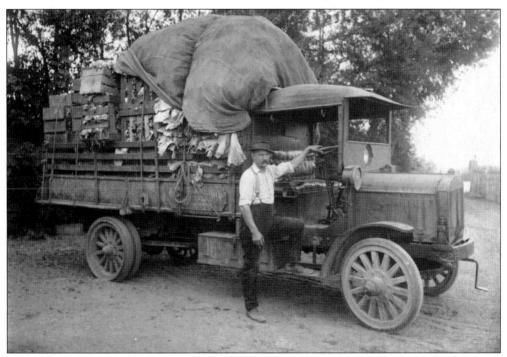

An elderly lady came to one of the author's first Sbrana photographic exhibitions in San Francisco and said that, when she was a little girl, she knew this man as "Natalo." This 1922 truck, with its vegetable load, is fully ready for market. The sign on the side of the truck, partially hidden by ropes, identifies it as belonging to "[?]ghlione Bros. & Co. San Lorenzo."

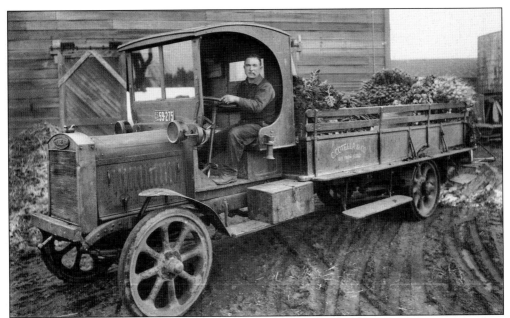

The sign on the side of this Moreland truck reads, "C. Cotella & Co. Bay Farm Island." The license plate identifies the date as 1924. This load of vegetables, including carrots, turnips, radishes and artichokes, looks ready to sold at market. The driver can also be seen in the Bay Farm Island group photograph on page 33.

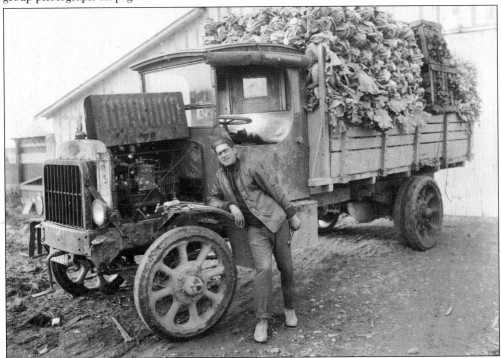

The name, date, and location of this photograph has not yet come to light. This no-frills Gramm Bernstein truck, with its roll-up canvas doors, solid rubber tires, hand-crank engine start (see front of truck), and horizontal steering wheel, was the newfangled, horseless wagon of the day.

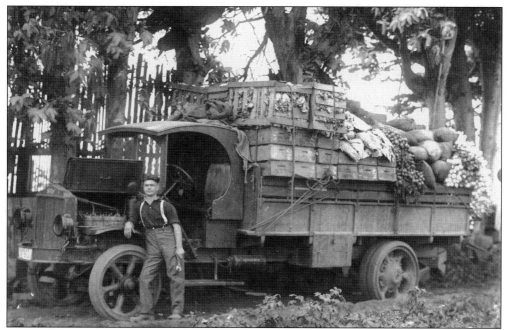

The location of this *c.* 1921 photograph is Alameda, and this vegetable truck is the same one seen in the photograph below. The various vegetables pictured include potatoes, celery, radishes, lettuce, and cabbage. This truck farmer, with wrench in hand, is Giovanni Caviglia. The image was identified in 1992 by his brother, Andrew Caviglia of Alameda.

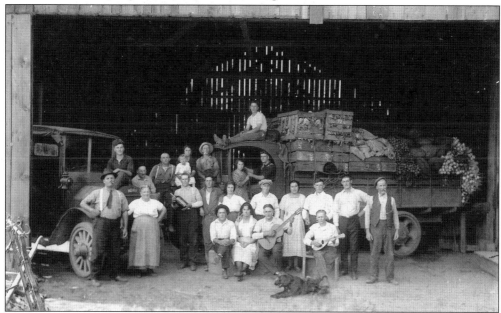

Andrew Caviglia identified this photograph, which includes Giovanni Caviglia (in truck), Teresa (mom) Ratto, Clara Ratto, Teresa Ratto, Joseph (Giuseppe) Ratto, Benedetta Canepa Ratto, Rosalia Ratto Caviglia, Giovanni (with guitar), Andrew Caviglia, Teresa Ratto Perata, Giacomo, Coleta, Pete Canepa, Joe Ratto, Moree, John Ratto, and Joseph Codino. This Alameda photograph was taken at the Antonio Ratto farm.

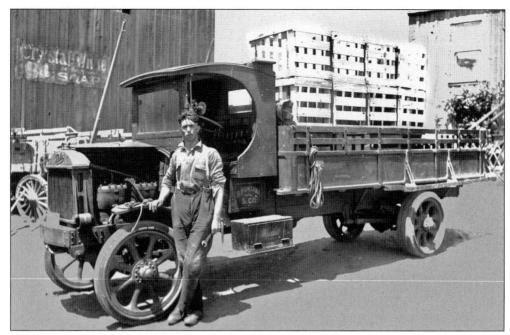

The lettering on the side of this 1923 Kleiber truck reads, "B. Fontana & Co." These doorless, solid-rubber-tired trucks were the prize possession of vegetable farmers who had just evolved from horses and wagons. "V. Fontana & Co." has existed in Colma since 1921, doing fine granite and marble work, but this "B. Fontana & Co." name did not ring any bells for 87-year-old Elio Fontana.

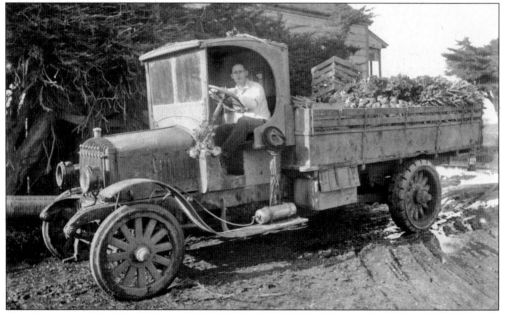

The writing on the side of this truck is barely visible, but reads, "C. Cotella, Bay Farm Island." Italians took full advantage of the coastal climates, especially in Alameda, to grow a wonderful variety of vegetables to feed people in towns all over the Bay Area, including Oakland, Berkeley, San Leandro, San Lorenzo, and Fremont, among others.

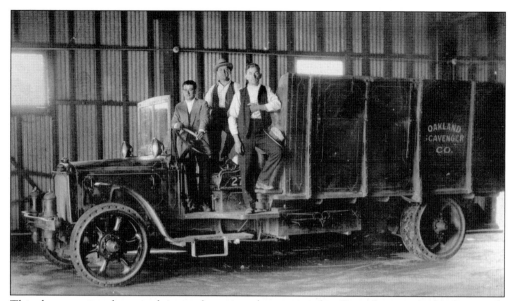

This glass negative photograph is merely copy work, meaning that Gino photographed a photograph and may have not been the original photographer for this early 1920s image of the Oakland Scavenger Company truck and three unidentified men. The number "27" can be seen below their feet.

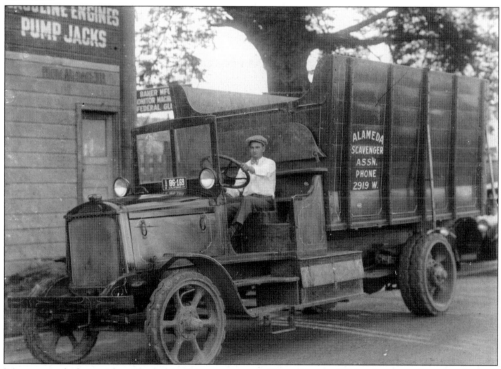

Many people have identified this driver as young Tom Perata. This photograph was taken in 1927 when he worked for the Alameda Scavenger Company. Many Italian immigrants worked for various East Bay scavenger companies, including those in Oakland and Alameda. A beautiful photograph of a group of scavenger workers is on page 27.

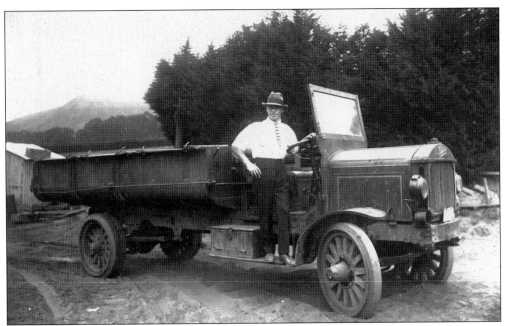

Marilyn Olcese, of Colma (now Napa), identified this truck as one that would have been used extensively on a hog farm. Angelo Fanucchi, of San Mateo, recently identified this person as possibly being his father-in-law, Ralph Caselli. This truck was made by Kleiber, and the date of the photograph is likely the early 1920s, possibly in Colma.

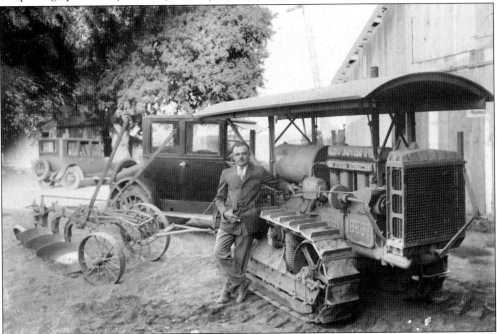

Gino took several exposures on this day of this unidentified man alongside the "Best 30" tractor. The original finder of these Gino negatives, Betty Workman, chose an exposure similar to this one, to become part of a stained-glass lamp shade. This interest in making lamp shades is the reason this collection made it out of the basement beneath Gino Sbrana's San Jose studio.

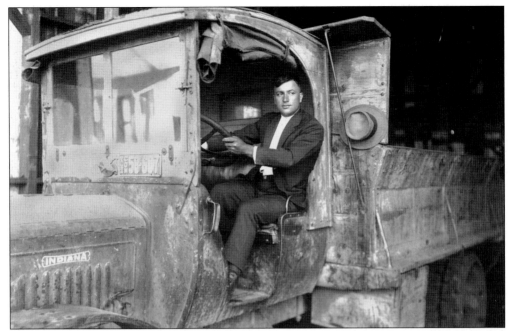

As in many of these Sbrana images, even when the farmers dressed in their Sunday best, they still were glad to be photographed with possibly their proudest possession, the vegetable truck. These trucks became essential to the vegetable-farming community and are probably why this business of vegetables was referred to as "truck farming."

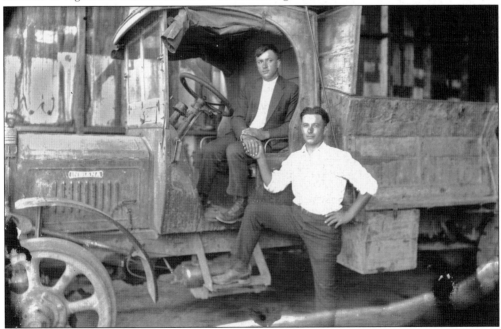

Here two men proudly hold hands in front of their 1925 Indiana vegetable truck. Due to the fact that Gino was so well respected and liked in the Italian community, the normally intrusive camera barrier is nonexistent in this photograph. Throughout Gino's photographic work, men routinely expressed their appreciation of their Italian brothers with hand holding.

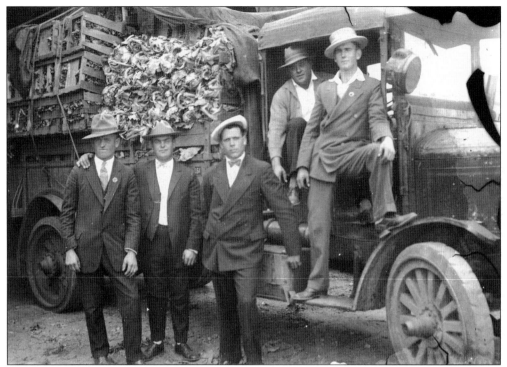

These five unidentified business partners appear to have their load of cauliflower ready for market. The emulsion of the glass negative has begun to separate and break off, and this is what has caused the black marks at the upper right.

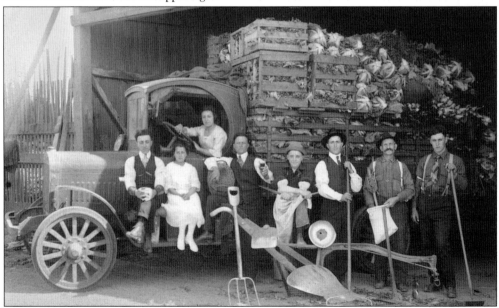

Gino always seemed to want to allow the story to be told with his camera. Here are, along with a fully loaded vegetable truck, eight proud members of the Italian Bay Area farming community. Some of the farm implements pictured here are a pitchfork, a horse-drawn soil tiller, two hoes, a bag of seeds, a rake, a knife, and the truck itself.

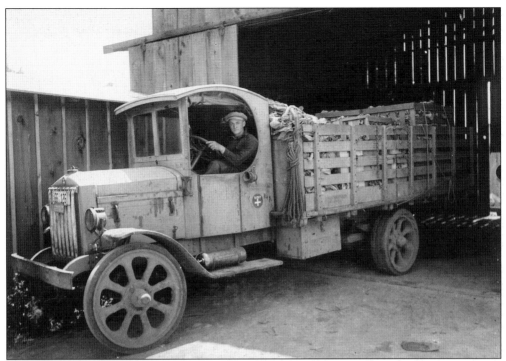

The location of this 1923 photograph comes from the handwritten "Colma," just to the left of the Italia flag emblem. Above this is written "E. Puccinelli & Co. 550 Front St." This truck closely matches the one in the Biasatti photograph below.

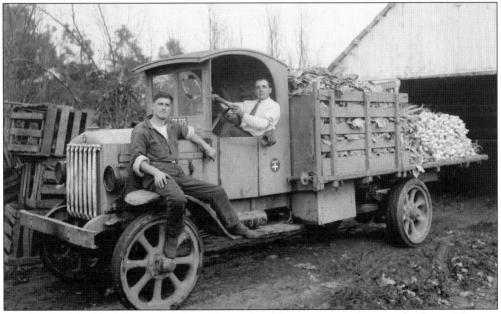

On the windshield of this vegetable truck is a decal featuring two diving girls. One of the two gentlemen pictured here in 1923 was identified as Santino Biasatti of Colma. This load of vegetables appears to include carrots, cauliflower, and white radishes. The Italia flag insignia is on the door and above the radiator grill.

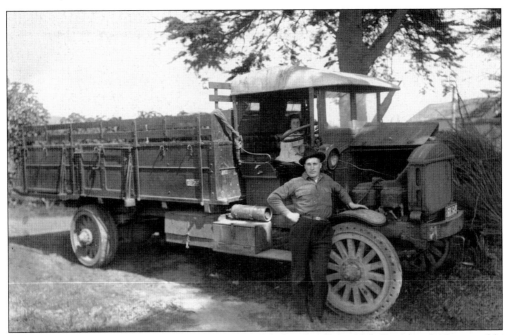

Even when there was hardly a place to find soft light, Gino would still try to find a suitable location. This farmer stands in the shade of a coastal cypress tree while his daughter waits in the cab of the truck.

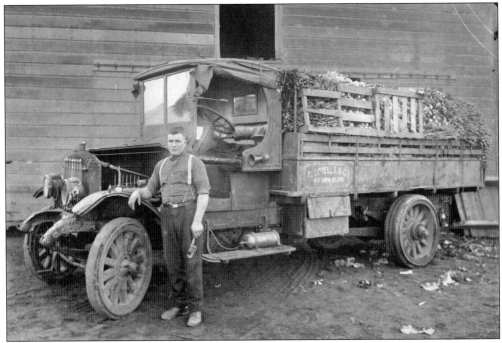

Many Italian farmers harvested their vegetable crops with their leaves still intact, not only for freshness, but also so that the leaves could be woven together to secure the heavy load without the use of wooden crates. Andrew Caviglia identified this driver as Tony Laverro of Alameda. On the side of this 1921 truck can be read "Cotella & Co."

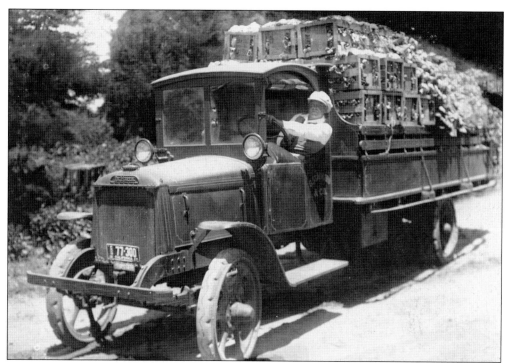

The name of the manufacturer of this produce truck is Demartini. The signage identifies it as belonging to "G. Stagnaro & Co.," while on the license plate, a date of 1927 is visible. Some of the vegetables going to market on this truck are cauliflower and radishes. The side of the crates reads, "Hamina Lettuce."

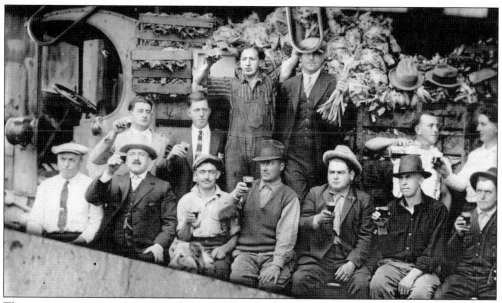

There are many copies of photographs in the Sbrana collection, including this one of 13 men holding vino next to a vegetable truck. The man sitting in the front row with the round face appears to be Silvio Landini, the constable of Colma. Yes, this may have been the days of Prohibition, but, law or no law, this was not going to stop most Italians from partaking in their love of vino.

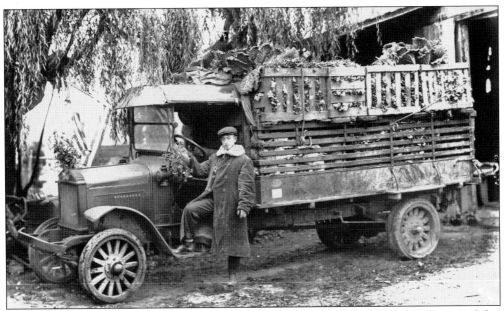

In 1992, Andrew Caviglia identified this young Italian as potentially being Sam Vallerga, and this was confirmed by his daughter Diane Sottile and Sam's wife, Rose Rubino Vallerga. Sam played a small part in the movie *Thieves Highway* in the 1940s as the guy at the San Francisco Produce Market who gives the main character a glass of water. Angelo Fanucchi identified this location as the Wholesale Train Depot in Colma.

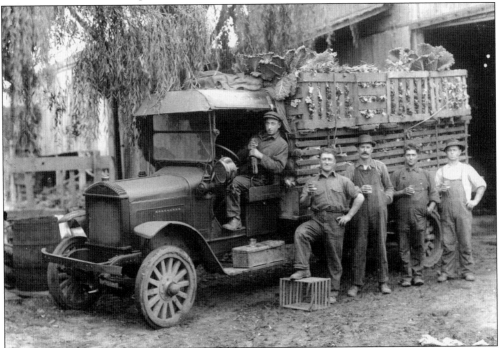

Gino photographed Sam Vallerga at least four different times this day in Colma. All five of these men are drinking vino, including Sam (holding the bottle). None of the others have been identified as of yet, although the man with the mustache does resemble Sam's father, Giovanni Vallerga.

Five

HORSES

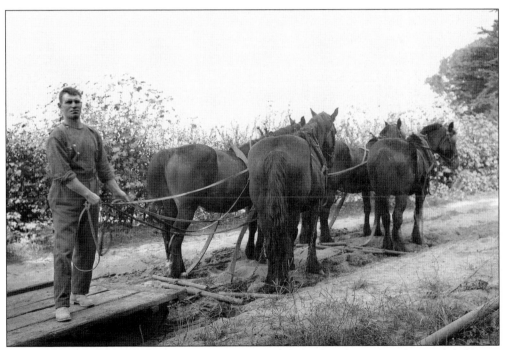

Johnny Rivera, of Colma, stands on a "slitta," or mud sled. These heavy wooden mud sleds were necessary in order to transport vegetables from the fields to the barns at times when the fields were unusually wet and muddy. Johnny was well known for both his strength and long hours of hard work put in each day, sometimes as much as 20 hours a day. This dedicated work ethic continued throughout his life. At the age of 88, he was still farming cilantro and mint.

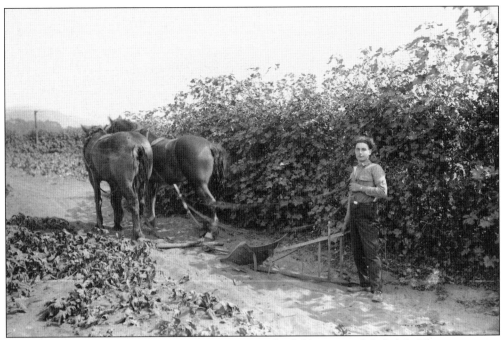

Gino, as one can see, did not hesitate to go out into the fields to record daily life. The young man pictured here with the plow and horses was identified as Manuel Stagnaro by his niece Lois Marin. This location is thought to be Westlake, near Colma, with the date being in the early 1920s.

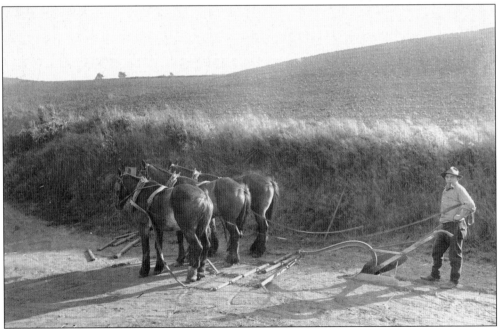

Where this man stands, with his three-horse team and plow, is a picture of peaceful serenity. These days, the Bay Area location is most likely quite hectic.

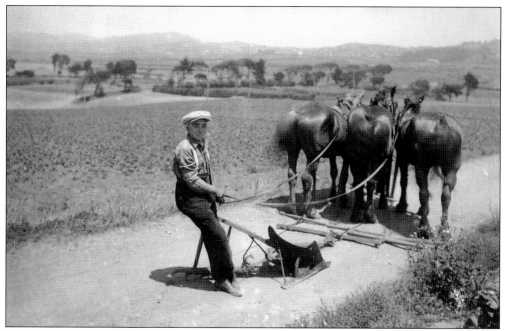

Luckily, Gino would sometimes photograph outside away from the barns, providing the modern viewer with a glimpse of the Bay Area as it was 80 years ago. Wherever this location is, Silicon Valley, San Jose, or elsewhere around the San Francisco Bay, one can be sure that today it is more than likely paved. This young man can also be seen on page 58 in the bottom photograph.

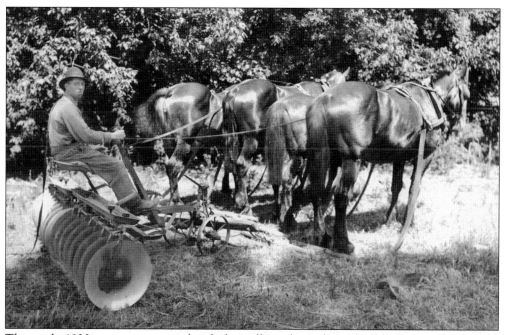

This early 1920s portrait is a study of what tilling the soil involved before gasoline super-industrialization took over, the short-lived link between brute strength and the gasoline-powered engine.

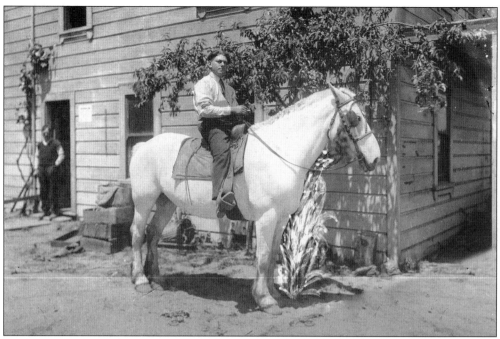

Horses were an integral part of a farmer's life, and seeing them around Colma, Daly City, Alameda, or other farming communities would have been a common daily occurrence. In the photograph above, in front of the horse carrying the man in the white shirt, someone has been painted over to create what looks like a plant.

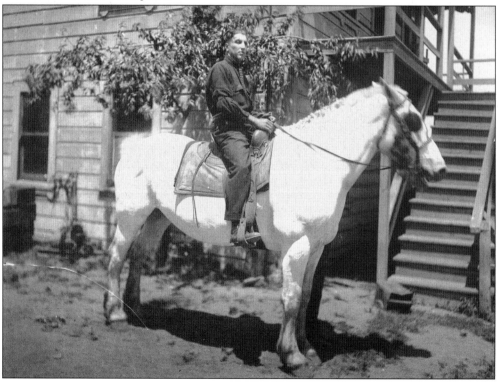

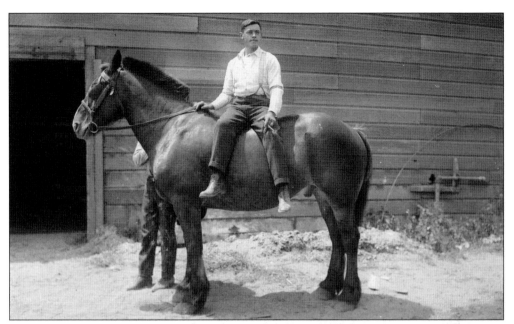

This Westlake photograph shows either Amadeo or Giuseppe Demergasso sitting sideways on a horse. Prized workhorses such as this one were, for generations, the foundation to the success of a farmer's life.

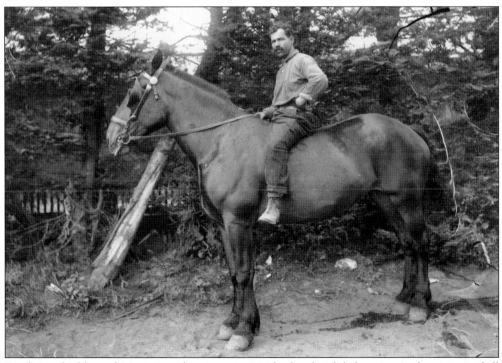

For those who like to do portraiture but possess no studio fitted with lights, timers, electricity, and all the rest of the modern hoopla, it is easy to see from the works of Gino Sbrana that a photographer does not need any of that stuff. With a keen eye for composition and lighting, one could be off in no time beginning to document this beautiful world very similarly to Gino Sbrana.

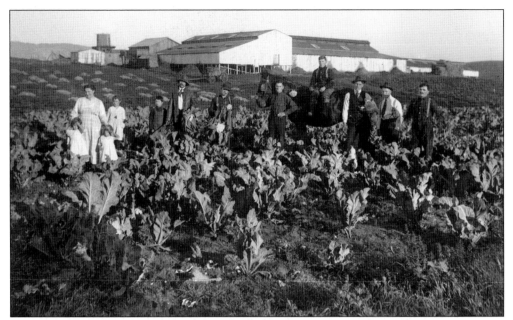

This is one of the rare instances where Gino took a group into an open field for a portrait. The contrast of outdoor sunlight was the reason Gino normally stayed close to trees or buildings. This is the exact same Demegrasso group seen in the photograph on page 44. Angelo Fanucchi recently identified this location as being the Westlake area between Colma and Daly City, toward the Pacific Ocean.

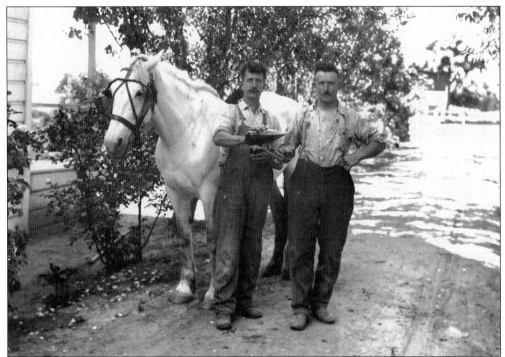

Any time was a good time to pour a glass of vino, as proven by this midday portrait by Gino. These two men, posing next to a white horse, have not yet been identified.

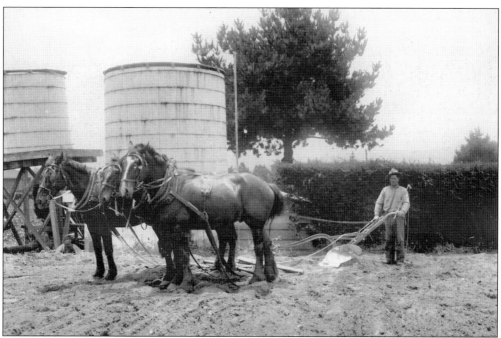

Many of these photographs seem to indicate that Gino had an interest beyond merely the portrait. When photographing on location as much as Gino did, there seems to be an intrinsic interest in preserving for the historical record a truer sense of what Italian life was actually like. Looking closely, below the head of the horse, one might notice that there is a young boy looking on.

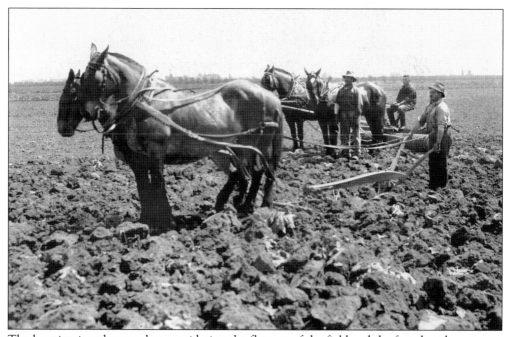

The location is unknown, but considering the flatness of the field and the fact that there are no hills whatsoever, it may be the flat hay fields north of the San Francisco Bay.

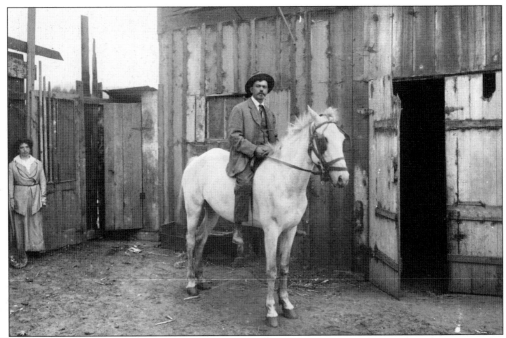

Mary Garibaldi identified this Colma photograph in 1992. The image shows Mary's father, Emilio Garibaldi, sitting on a white horse, with Mary's mother, Catarina, on the far left side of this image. Mary Garibaldi, as a very young girl, is also featured on page 46, posing with her family on the front porch of their house.

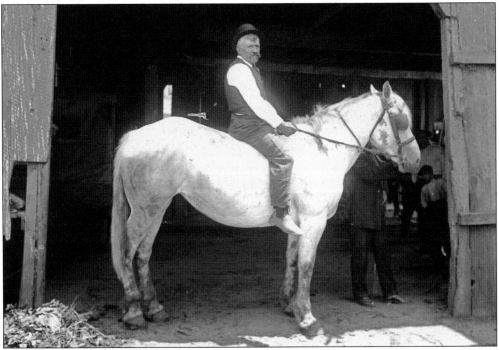

This man was identified as "Casanova." This image of a man on a white horse once again reveals how the entrance to the barn was a preferred portrait location.

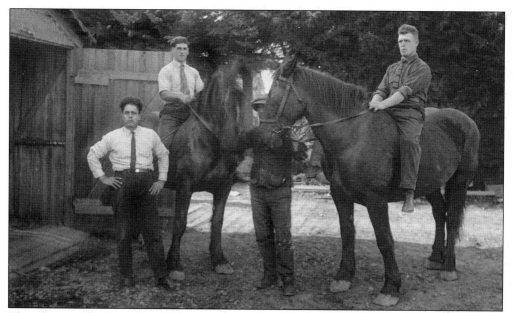

This photograph was most likely taken in Colma. The men pictured here were identified by Andrew Caviglia as Marcello Siri (standing on left), Bert Pastorino (on horse), and John Ratto (nickname "Gresia") on the horse at right.

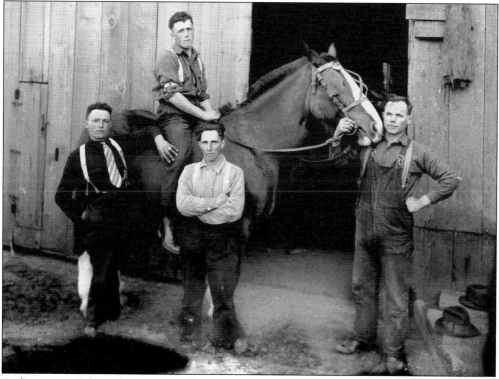

At least two of these four men can be seen in the 1924 photograph on the cover of the book (standing on the right). The man in the middle, wearing the light colored shirt, looks to be one of the men seen in the bottom photograph on page 92.

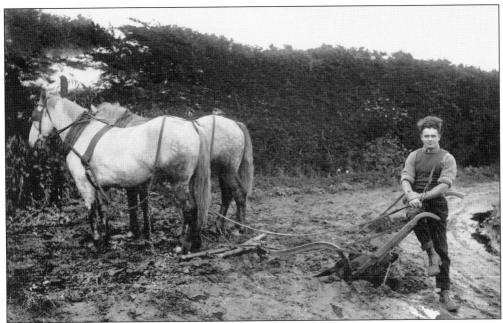

Andrew Caviglia identified this young man as being Giuseppe Siri. The author recently interviewed Frank Siri, age 90, who farmed in the 1920s near the Cow Palace. Even though Frank greatly resembles the Siri seen here, he did not believe he was related. Frank did give an account of horse-and-cart vegetable farming back in the old days, before the use of the truck.

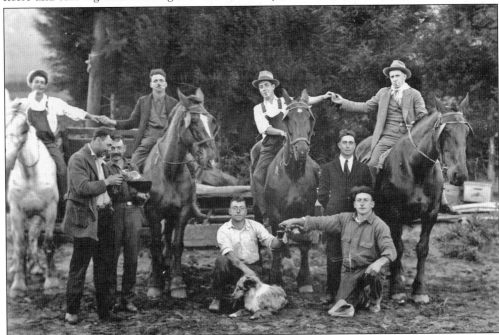

Andrew Caviglia identified this group to be from Colma, and at least one person to be of the Damelli family. This group of nine men, four horses, and one dog is one of Gino's more elaborate compositional challenges. As documented throughout this book, vino seemed inseparable to the living of life and was a featured centerpiece in a great many of Gino's images.

Six

CARS AND MOTORCYCLES

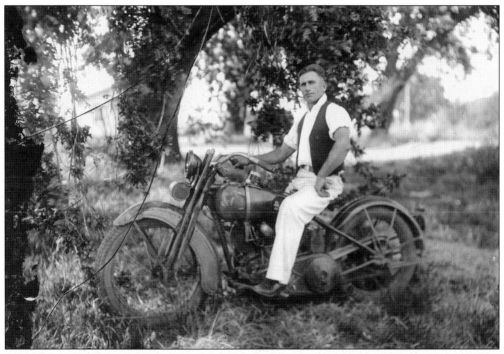

This photograph has long been one of the most popular photographs from the Gino Sbrana collection. The initials W. E. B. can be read on the Harley Davidson gas tank. Hopefully, this will be enough of a clue for someone to identify this person. High-quality prints of every image seen in this book are available in any size. The acknowledgments on page 6 contain information on how to contact the author with any questions, to order a print, or to contribute information relative to these images.

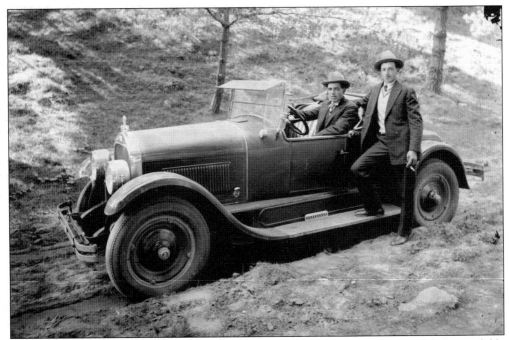

Gino, as in the images on these two pages, would take full advantage of the soft light available beneath trees. At the center of the tire can clearly be seen "Fiat." The names of these two men have not yet been discovered.

This early 1920s photograph is a fine example of both Gino's compositional talents and his eye for finding soft lighting perfectly suited for full tonal range negatives. The man on the right can also be seen on the cover of this book (second from right in back) and in the bottom photograph on page 87. The man on the left resembles the famous John Dillinger.

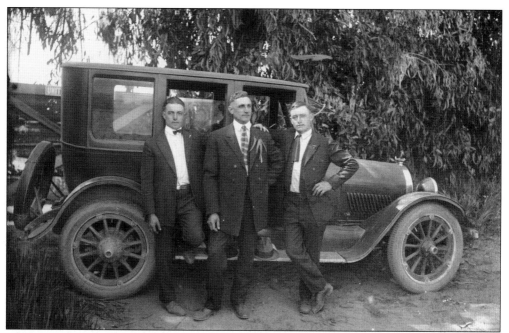

The man standing in the middle, with the eucalyptus leaves on his suit coat, was identified by Andrew Caviglia as Joe Cerruti. The location was thought to be Bay Farm Island. Historical records indicate that the island of Alameda was originally a peninsula and that the peninsula of Bay Farm Island was originally an island.

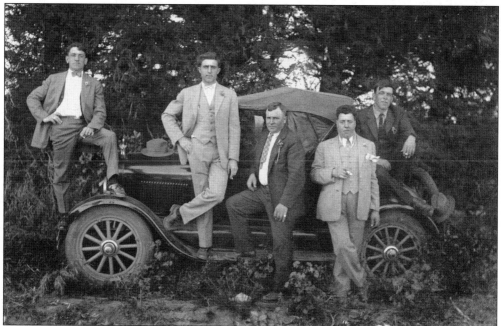

Gino always made use of soft-lighting conditions, such as here, where, in the 1920s, he photographed this Alameda group of five men posing on a convertible car between a vegetable garden and a row of cypress trees. One of the men was identified by Andrew Caviglia as Tony Laverro (center) and another as Pertino.

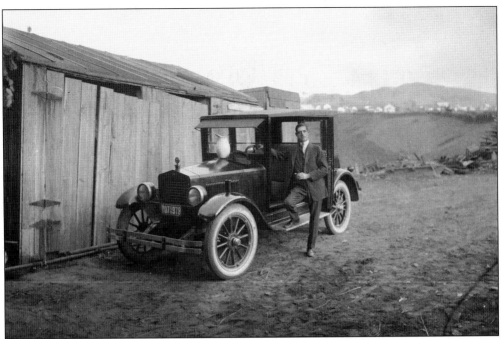

Here is another one of those rare photographs revealing a glimpse of the actual location. This man, who proudly stands next to his 1923 Essex car, was identified as being John Griniola at the Armenio Ranch. John Griniola was the godfather of the person who identified this photograph.

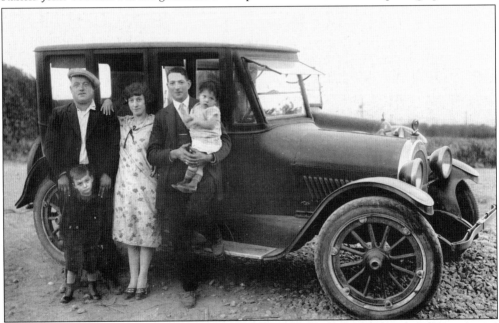

The man on the left greatly resembles Silvio Landini (the constable of Colma) who is also pictured on page 64. The two children and the other two adults are still waiting to be identified. Once this book is published, more and more knowledge will begin to surface to help in identifying who is who. Then connecting the dots and finding cousins, grandfathers, mothers, nephews, uncles and other family members will become easier and easier.

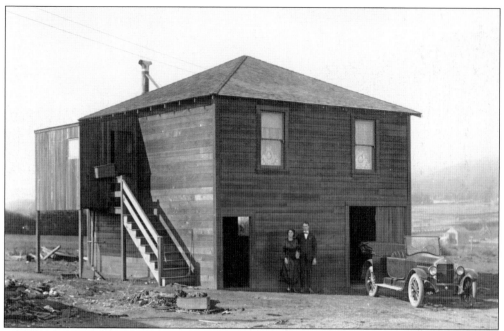

The location of this photograph, depicting an unidentified man and woman standing next to their house, is unknown. As one can see, once upon a time, there was elbow room in the Bay Area. According to the book *North Beach*, there were as many as 57,000 Italians living in San Francisco alone in the early part of the 1900s.

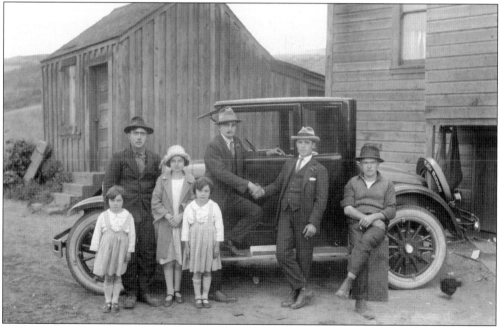

In the background, the hills are free of the graveyards for which Colma is now well known (where the dead outnumber the living and bumper stickers read, "It's great to be ALIVE in Colma"). This photograph was identified by Elsie Pollastrini, who is the little girl wearing the hat. Others in this photograph are Marie, Rose, and Giuseppe or Amadeo Demegrasso.

Here a young, well-dressed man poses next to his early convertible Model T (Tin Lizzy) automobile, with a foot on the running board. The average miles per gallon of a Ford Model T was 25 in 1908. The average miles per gallon of a car in America today is about 21. What is wrong with this picture?

Gino photographed this family, with their early 1920s Nash automobile, in the soft light beneath eucalyptus trees. Pictured here are Mary and George Cipresso along with daughters Giuseppina and Bina. (The spelling of Cipresso is uncertain.) Joe Anguillo identified this 1920s photograph taken in Colma. Mary and George can also be seen on page 40 in the Colma group photograph.

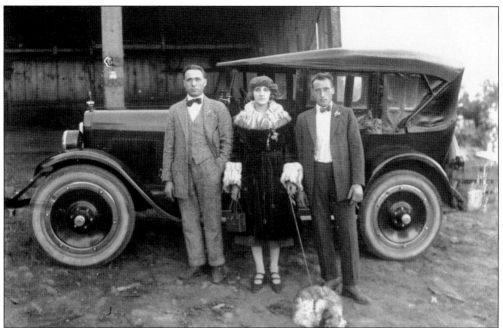

This *c.* 1915 group is from San Francisco. Their names, from left to right, are Ernest Piazza, Ilide Piazza, and Silvio Piazza. This photograph was identified by Aurora, daughter of Ilide. Most of the photographs seen in this book date after Gino's Pisa Foto years (1912 to 1915?) in San Francisco. This image is one of the few exceptions.

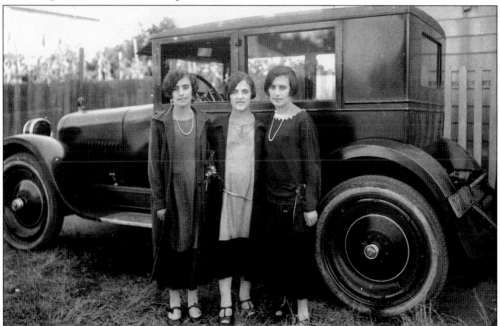

These three young women were identified by Frances Freccero in 1989 as Isabella, Maye, and Marning Perata of Alameda. The author's notes are incomplete, but he believes all three were Perata. Whether they are cousins or sisters, he is not sure. The date, which can be read on the license plate of the Hudson Super Six, is 1925.

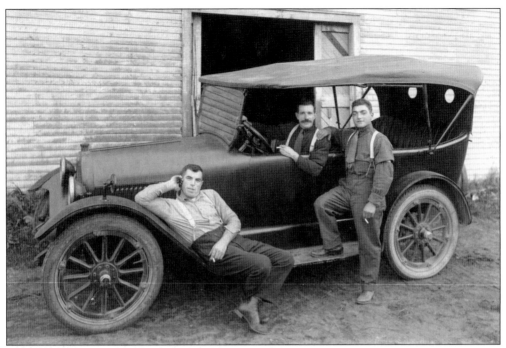

This 1922 photograph from Alameda was identified by Joann Freccero and includes, from left to right, Anthony Freccero, Fracceri, and "Strong John."

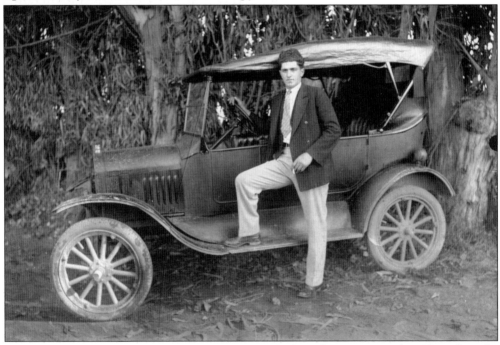

This is a 1921 photograph of Bocci "Lungo" Ratto of Alameda. As a reminder, Alameda is the island (formerly a peninsula) just north of Bay Farm Island (formerly an island). This photograph was identified by Andrew Caviglia, among many others. Many relatives of Bocci Ratto can be found still living in Alameda.

This unidentified man, sitting on the running board of a 1920s Nash automobile, is holding a rifle and a holster with extra ammunition. No records were left to document the glass negatives of Gino Sbrana. This is why so many of these faces and places remain a mystery.

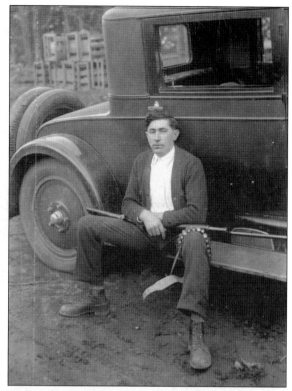

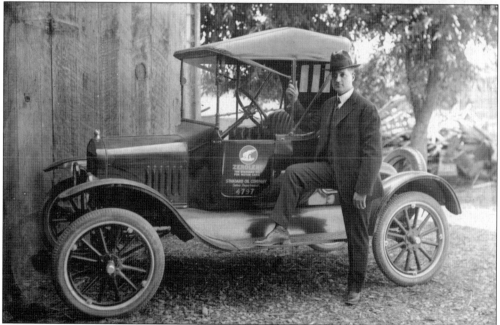

The side of this early Ford Model T reads, "Zerolene the Standard Oil for Motor Cars, Standard Oil Company, Sales Department, 4797." This photograph was taken anywhere from 1915 to 1925. One of the early gasoline distributors for Standard Oil, in the Half Moon Bay area, was Bill Miramontes.

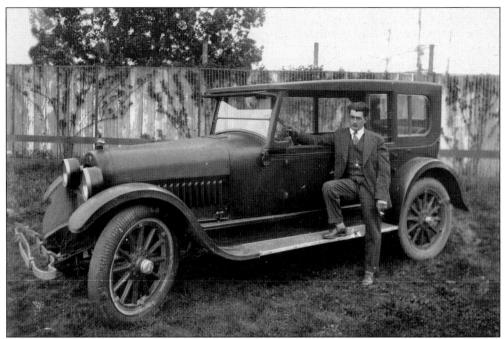

Gino took this photograph of Andrew Perata next to his car sometime in the early 1920s, more than likely in Alameda. In the background, three masts on a ship in the harbor can be seen. This photograph was identified by Andrew Caviglia of Alameda in 1992.

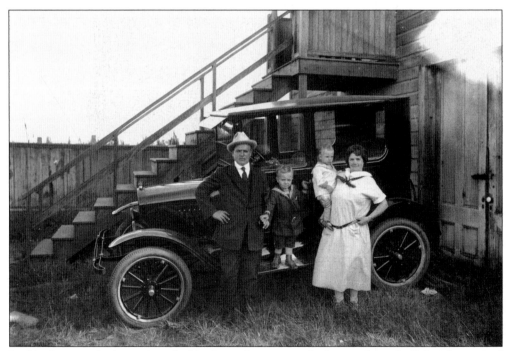

In this photograph, the car is parked in the yard up next to the house where the light is best suited for portraiture. This family is still waiting to be identified. The two little boys and the mother have on sailor outfits, inspired by World War I.

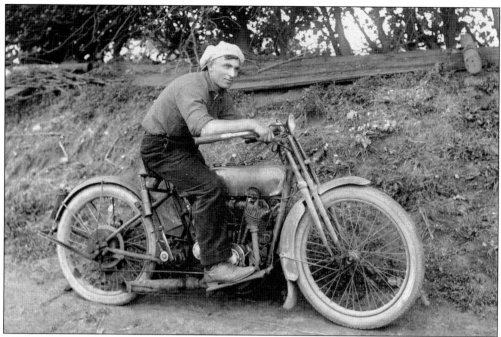

Andrew Caviglia identified this motorcycle rider as perhaps being Angelo Stagnaro, of Colma. On the side of the gas tank is the well-worn name of Harley Davidson. This early Harley dates as far back as 1915. Angelo Stagnaro, of the San Francisco Flower Growers Association, just informed the author that he is a distant relative of this earlier Angelo Stagnaro.

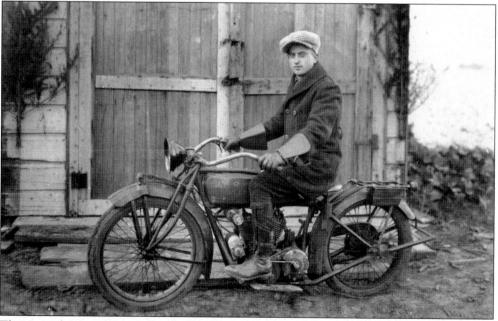

The nameplate on the gas tank reads, "E. F. Rossi, San Pablo Ave., Oakland, Cal.," and on the motor is written "Bosch." This photograph dates from around 1918. The rider of this early Rossi motorcycle is Adriano Corioni, identified by his grandson Tony Lassalle. Adriano, wearing extended leather arm and shin guards, is well prepared for riding, except for a helmet.

Under a 10-times magnification loupe, it is possible to read at the center of the tire that this immaculate 1922 car is a Hudson Super Six from Detroit. Gino's negatives are microscopically sharp and have the ability to be enlarged more than 1,000 percent without showing the grain of the emulsion. These two Bay Area people are unidentified.

From left to right are Bocci Cipresso, Anthony Freccero, Pete Rostagno, and an unidentified man. This photograph was taken in Alameda in 1922. This image was enlarged to six feet and hand-tinted for the Gino Sbrana photographic exhibition in 1989 at the San Francisco Festa Italiana. Joann Freccero, daughter of Anthony Freccero, identified this photograph at the Festa Italiana.

Seven

WHITE SHEETS

At the 1989 Festa Italiana, where the Sbrana imagery was on display, a lady came by and looked at this particular photograph and said, "I think I know who this man is, and he is here today." Fifteen minutes later, an elderly gentleman came shuffling up to take a look at this image, and said immediately, "It'sa me'a, it'sa me'a," and then began to cry. John Garibaldi Sr. had not seen this photograph since the early 1920s, when the image was taken. In this chapter are examples of the many instances in which Gino had an assistant hold up a white cloth to help bounce light so as to reduce contrast. Gino's original intent was possibly to crop the portrait, leaving out the white sheet, thereby resulting in more of a passport-style photograph.

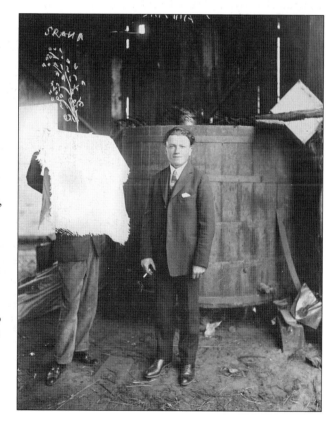

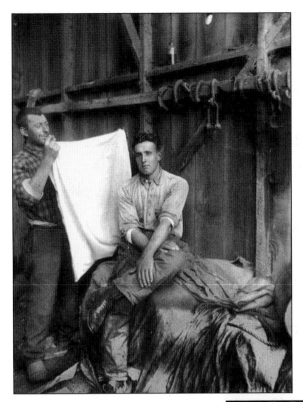

Once portrait photographers actually see these Sbrana images, they will begin to understand the advantages of both being on location, as opposed to in studio, and of natural light, as opposed to artificial. Hopefully, through the visual understanding of Gino's work, there will be inspired others to carry on in the manner and style of Gino Sbrana.

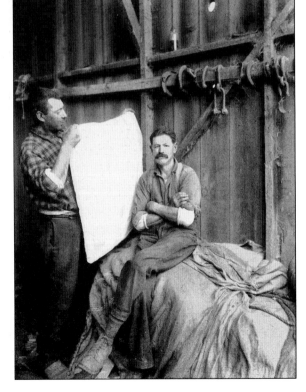

With all that is going on in this photograph, such as the hanging horseshoes, the burlap blankets, the side man holding up the light reflector, and the barn's rustic ambience, one can certainly gain a more complete understanding and feel for a farmer's life 80 years ago.

These down-on-the-farm images Gino captured are amazingly intriguing, not only for the forgotten Italian story being visually told, but also for the timeless simplicity of technique and mastery of light that Gino evidences consistently throughout his photographic work. These two men are waiting to be identified.

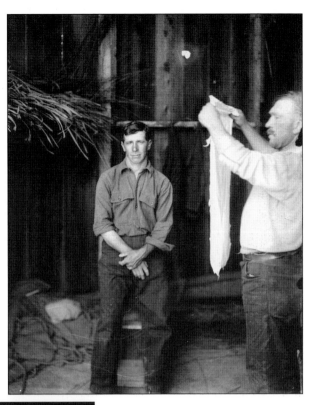

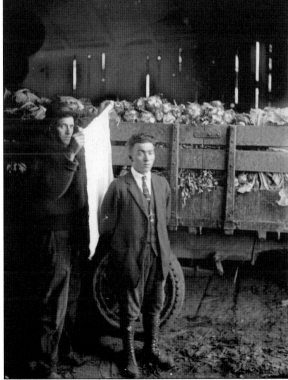

It is unlikely that a studio photographer would ever end up with such a composition as pictured here. As can be seen throughout this book, each of Gino's images reveal a visual ambience bordering on minimalist naivete—artistically speaking, of course. This style of spontaneous improvisation, based on the organic circumstances of the immediate environment, dates back to the 1800s with Italian photographers.

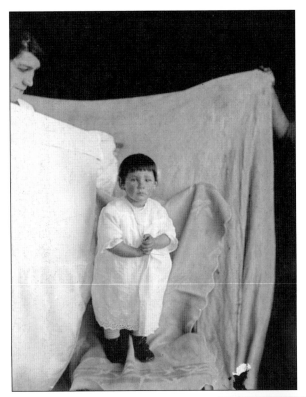

When a photographer's studio is on location, no two photographs are ever the same. Most portrait photographers stay hermetically sealed in the indoor studio, where all variables remain constant. Gino's ability to master the exposures, the focal planes, and the continuous compositional challenges from location to location, when all variables are in constant flux, seems almost to be a lost art.

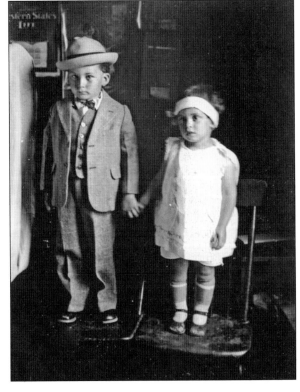

Who needs a portrait studio when a window, a chair, and a white cloth can get results like this? Here an unidentified brother and sister, very stylishly dressed, hold hands while standing on a chair for this early 1920s photograph. The author wonders if anyone knows what ever became of these children.

The original Sbrana negative had a pillow painted over this man's face. Not until the author decided to rinse the paint off did he recognize this father to be Anthony Freccero, who is holding baby Angelo. This painting over of the face indicated that Gino's intent here was to crop in around just the subject matter or face leaving a passport-type photograph.

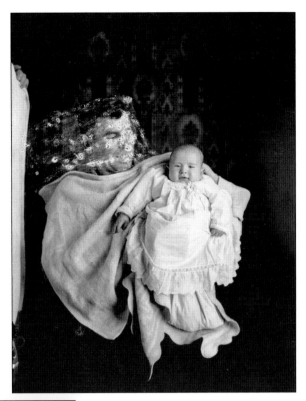

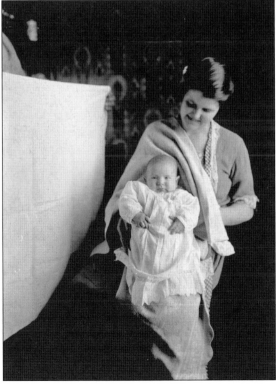

This Alameda photograph is of Angelina Freccero holding baby Angelo. The white cloth seen here helps to reflect light to reduce contrast.

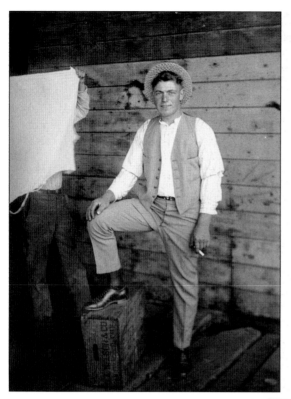

It is a safe bet that when Gino came around to take photographs, these Italian farmers and ranch hands would do their best to dress up for the occasion. The people that Gino photographed were, for the most part, Italians who may have not otherwise ever had pictures taken of them. In many instances, these images represent the only surviving likenesses of these Italians whom Gino photographed.

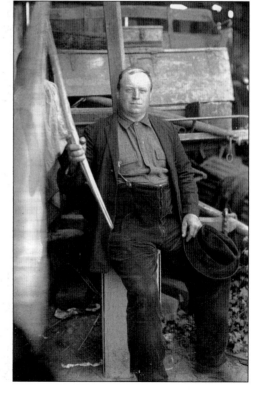

This image is rather amusing in that, apparently, no one was available to hold the white cloth reflector up, so the sitter himself takes matters into his own hands. A stick with a white cloth draped over the end appears to be the answer to softening the contrast.

When assembly-line-loving studio photographers were cranking out one-pose-fits-all portraits, year after year, Gino treated each composition according to circumstances uniquely available from location to location. This organic mastery of the elements led to a fruition of a photographic ambience far more individualistic and aesthetically pleasing and captivating than the sterile imagery originating from the confines of indoor portrait studios.

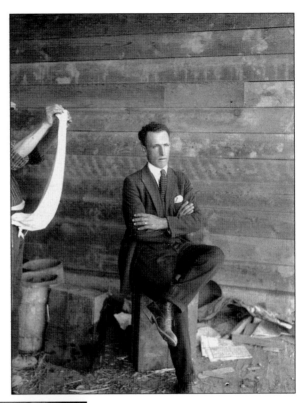

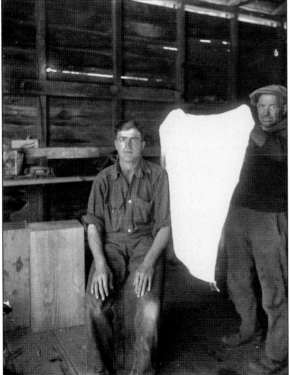

This is a photograph of an unidentified man sitting in a barn on a wooden crate. Once again, the holder of the white cloth is included as rather an incidental, almost accidental, part of the background. However, the story is far more interesting, relative to Gino's techniques, when the full picture is made available.

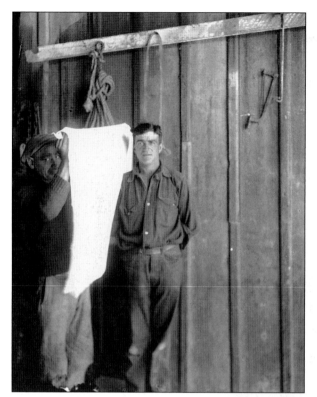

At six feet, one inch tall, Gino generally was always focusing slightly down on most everyone, meaning that when he focused on a face, the feet would be out of focus. This could have been easily remedied, but Gino preferred to isolate the field of focus to solely the face.

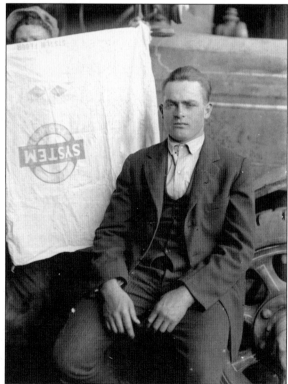

Even though all these trucks seen in this book look very utilitarian and practical with no frills (like doors), it is possible to discern the pin-striping detail work, even on the rims of the solid rubber tires.

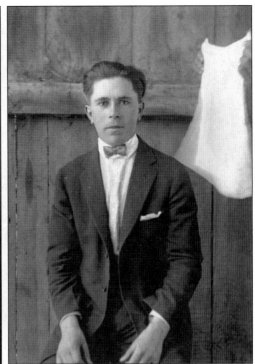

Whether or not any other photographer ever used the white cloth reflector as often and as unhesitatingly as Gino did is difficult to say. The years of studio portrait work, where the softest of natural light was available, undoubtedly led to his ever-present desire to seek out soft lighting conditions. This may be why these white cloth reflectors were so extensively used by Gino.

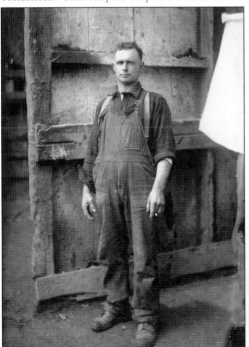

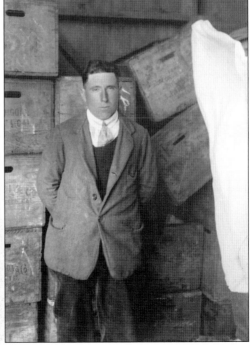

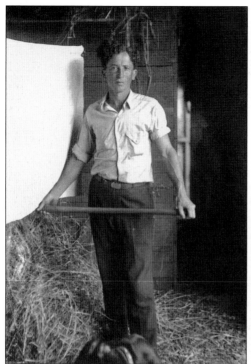
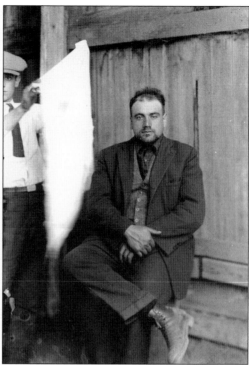

Extremely large wine barrels sometimes show up in the background of Gino's portraits, as is the case in the bottom left image. More than likely, these men are all somehow related to truck farming. The young boy holding up the white cloth in the upper right image is likely Gino's young assistant and nephew, Phil Brunetti.

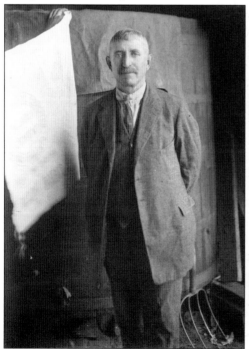

How many other historically significant treasures of photographic images are being overlooked is difficult to say. It is a minor miracle that Gino's collection of glass negatives survived as it has. Of course, in an enlightened society, both at the state and national levels, there would be efforts made to assure all such imagery would not be lost to oblivion and would be saved and treasured for the benefit of all.

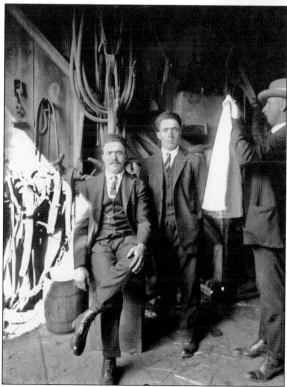

This photograph is of Vittorio and Amelio Cervello of Colma, c. 1921. The 160-plus names that have been discovered so far in this collection are merely a foundation for those who may wish to trace the ancestral roots of those whom have gone before them.

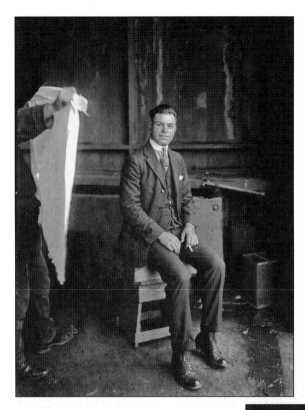

Gino kept no records, as far as can be discovered, of exactly who is who in any of these photographic images. There is a chance that a great many of these negatives may have been printed only once for the customer, while many may have never been printed at all.

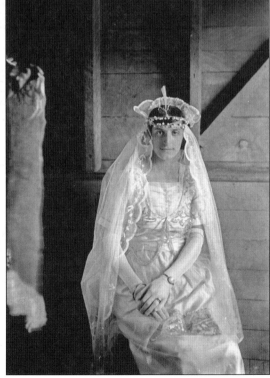

As can be seen in this chapter and throughout this book, whether the subject was a well-dressed businessman, a baby, a ranch hand just in from the fields, or even a bride on her wedding day, chances are good that if they were photographed by Gino, a barn somehow played a part in the image.

Eight

SAN JOSE, 1928

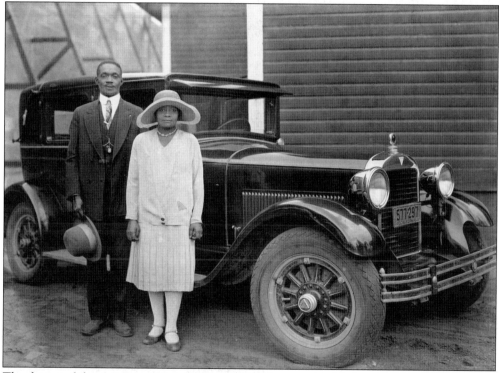

The dating of this image comes from the license plate on this Hudson Super Six, which reads 1928. This chapter includes only images from film negatives that were recently given to the author by Andrew Brunetti, Gino's nephew. In the original glass-plate collection, there was only one image of someone of African descent. In these new negatives, again, there is only one. Since Gino quit driving much after his car accident, all the images in this chapter are more than likely from around 1928 in the San Jose, Santa Clara area. As represented by the images in this chapter, his abilities as a photographer were never compromised, even if his ability to travel around the Bay Area was.

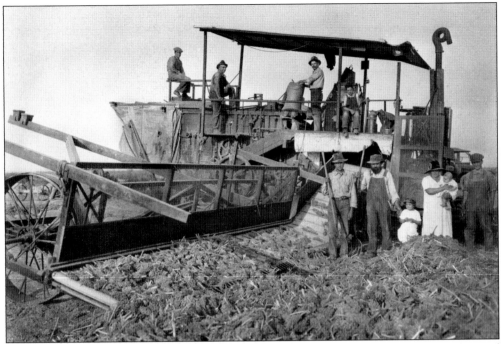

The crop being harvested by a combine appears to be kale. The subjects include a mother and baby, two young children, and six farmers.

Gino was not a landscape photographer, for every single image contains a portrait of someone in the Bay Area. Information regarding the identity of this man on his boat will hopefully come to light with the publication of this book.

After his car accident, Gino rarely traveled by automobile up to Colma, Alameda, and elsewhere around the San Francisco Bay. Instead he stuck close to his home in San Jose. All of the photographs in this chapter, including this one of two men at work at a lumberyard, are more than likely in close proximity to San Jose.

This family of five standing outside of their house by a picket fence appears to be Mexican. Gino's neighborhood (Locust Street), which was once all Italian, has now become, for the most part, all Mexican. Of course, California was Mexico in the not too distant past.

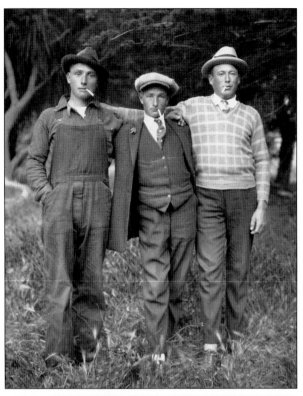

These two exquisite images of young men capture an ambience of days long forgotten. Gino's low-tech, high-skill abilities, in conjunction with an ever-present respect and reverence for those he photographed, led to his consistent mastery of photography.

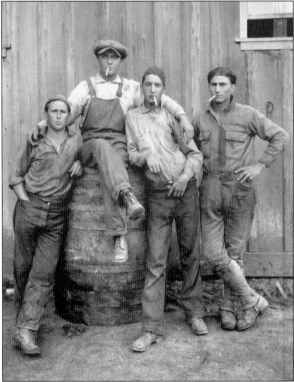

Even after his car accident, when he suffered chest injuries and began to suffer later in his life from severe migraine headaches, Gino's interest and his ability in photography does not seem to have diminished one iota. Some of the images in this chapter would qualify in anyone's book as timeless masterpieces of photography.

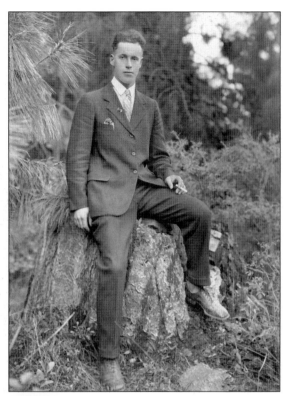

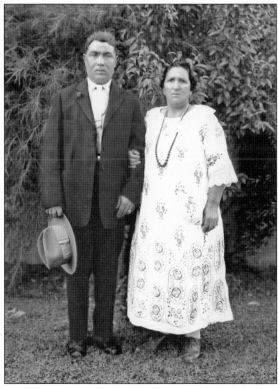

Except for the fall 1992 issue of *La Peninsula* (published by the San Mateo County Historical Association), not a single image in this entire book has ever been published. The Sbrana Hand-Tinted Mural Exhibit is the only opportunity the public has ever had to see this exquisite imagery.

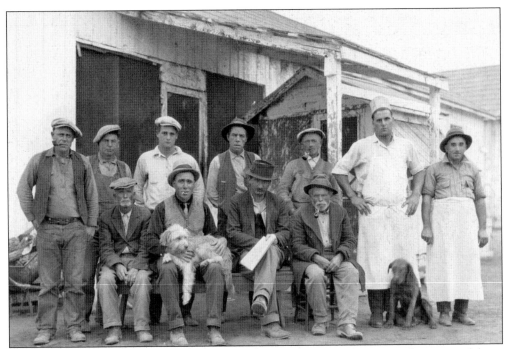

Since Gino quit traveling extensively after 1925, the images in this chapter can be narrowed down (more than likely) to either San Jose or Santa Clara. The people Gino photographed seemed to still mostly be Italians. However, as shown in this chapter, there was a bit more diversity.

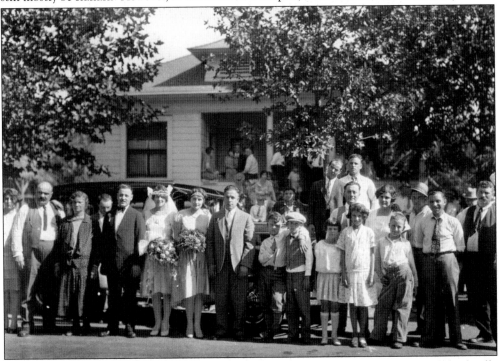

This wedding group image was taken in San Jose c. 1928. Now that these images will be finally seen after 80 years, the rest of the story will begin to unfold.

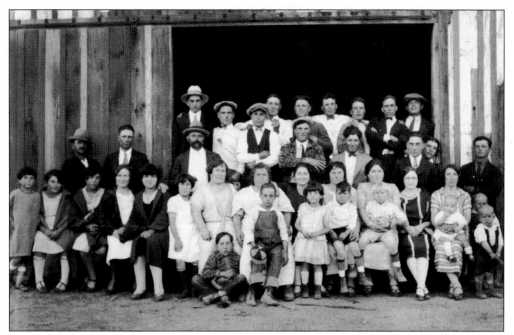

This large group of 38 men, women, and children was photographed either in San Jose or Santa Clara. The two adult women in the center (with the white dresses on) seem to be only a few inches taller than a small child. Some in this group appear to be Mexican.

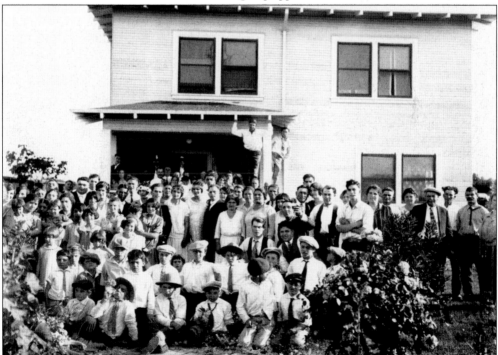

This celebration photograph of approximately 75 people was taken in either San Jose or Santa Clara. The true facts and stories of these Sbrana images will someday come to light after this book is published.

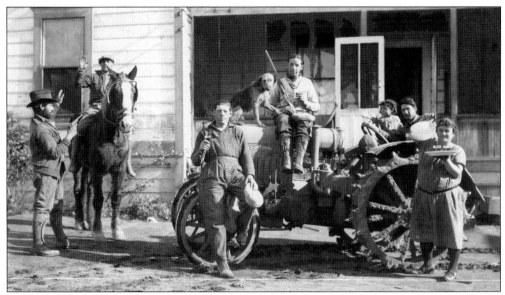

The four photographs on these two pages are the most unusual of all the Sbrana imagery. Here can be seen a man holding a gun at a boy on a horse, a four-foot-tall woman pouring vino, and a dog posing with its paw up on a young boy holding a shotgun and glass of wine.

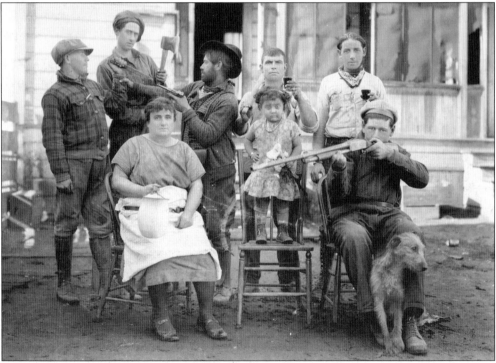

This is, of course, what everyone does in their spare time: serve wine to their kids, play with hatchets, and aim rifles and guns at each other. No? At any rate, these people are having an unusually fine time. Gino was described as a romantic bohemian who loved to sing opera at community gatherings. The rather theatrical antics represented on these two pages were probably quite welcomed by Gino.

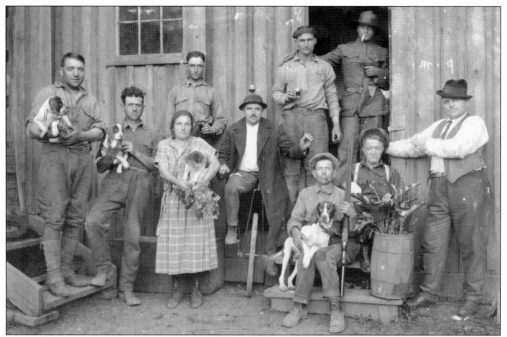

In this 1928 photograph, there are four dogs, one shotgun, two guns, three glasses of vino, flowers, a barrel of calla lily leaves, a man in a World War I uniform holding a pistol, and a man on a unicycle balancing a glass of wine on his head. For the most part, the Italian community escaped the federal mandate of living alcohol-free during Prohibition.

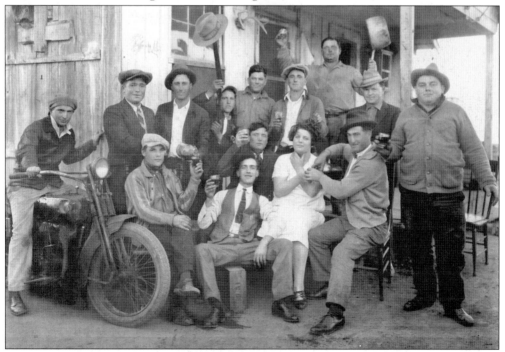

This photograph features at least seven glasses of vino, one guy on a motorcycle, one hat hung on the end of a shotgun, and several faces showing signs of having a good time.

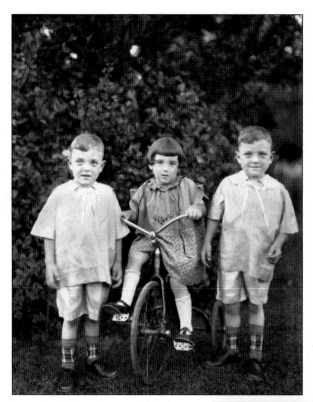

Maybe the boys are not twins (one is a bit taller), but with matching shoes, plaid socks, shorts, shirts, and haircuts, they sure seem to be a matched pair. These three will hopefully be someday identified. The images in this chapter were saved thanks to Gino's nephew Andrew Brunetti.

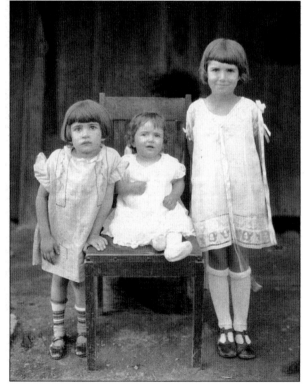

Even though much information is absent from the Sbrana imagery, at least now the many stories written about the Italians of the San Francisco Bay Area can have a visual perspective. Hopefully, some of these children will still be around to add to this ongoing story of the Italian presence, which has so beneficially contributed to the cultural well being of all of California.

This image is reminiscent of the timeless expressions of the 1840 and 1850s. Each image in that era of photography captured a period of time, usually two to five seconds, due to the low light sensitivity of the emulsions, resulting in an ambience of universally calm expressions. Once film emulsions became more light sensitive and shutter speeds quickened, the portrait became a record of an emotion momentarily existent. Gino's style was a throwback to the 1800s.

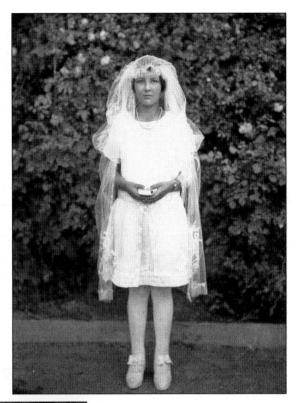

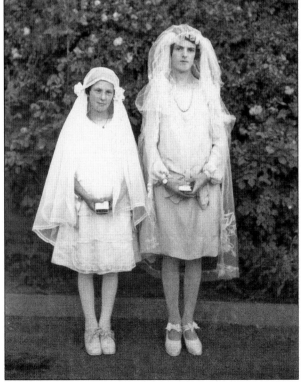

As the author has said over and over, the timeless simplicity of Gino's technique is beautifully captivating. None of the images in this chapter have ever been seen before, so consequentially, they all start this journey, looking to be identified by friends and relatives, right here in this book.

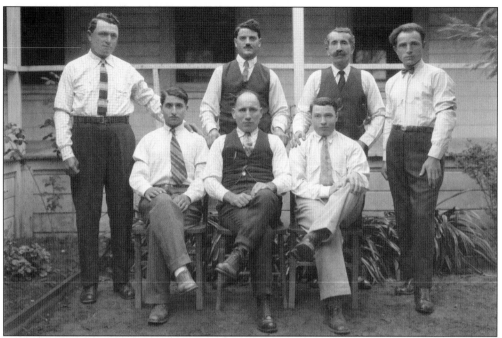

No confirmed image exists in the Sbrana collection of either of Gino's brothers, Olinto or Carlo. Gino's 87-year-old nephew Andrew Brunetti did not recognize the group pictured here.

Gino's on-location style could be considered a missing link between the early days of itinerant photographers who traveled from town to town and those commercial photographers of the modern era who have every convenience in the world. With one functional darkroom in place, Gino saw the entire San Francisco Bay Area as his possible portrait studio.

Gino took at least seven photographs this day at this location. Five of the images were a different arrangement of family members, with the one constant in all five being the young man seen on the right in this image.

How else to end this story but with this image of a bunch of Italian men drinking vino? Should anyone recognize family or friends in the photographs seen in this book, feel free to contact the author. Further names and references will be updated on-line for further historical documentation of the Gino Sbrana imagery.

ACROSS AMERICA, PEOPLE ARE DISCOVERING
SOMETHING WONDERFUL. THEIR HERITAGE.

Arcadia Publishing is the leading local history publisher in the United States.
With more than 3,000 titles in print and hundreds of new titles released every
year, Arcadia has extensive specialized experience chronicling the history of
communities and celebrating America's hidden stories, bringing to life the people,
places, and events from the past. To discover the history of other communities
across the nation, please visit:

www.arcadiapublishing.com

Customized search tools allow you to find regional history books about the town
where you grew up, the cities where your friends and family live, the town where
your parents met, or even that retirement spot you've been dreaming about.